COMMONPLACE

David Plowden

COMMONPLACE

A CHATHAM BOOK
Sunrise Books/E.P. Dutton & Co., Inc.

This book was jointly conceived with Chris Harris, of The Chatham Press, whose editorial vision is reflected on every page.

—D.P.

FIRST EDITION

10 9 8 7 6 5 4 3 2 1

Published simultaneously in Canada by Clarke, Irwin & Company
Limited, Toronto and Vancouver
ISBN: 0-87690-143-7
Library of Congress Catalog Number: 74-81420

DESIGNED BY CHRISTOPHER HARRIS

Dutton-Sunrise Inc.,
a subsidiary of E.P. Dutton & Co., Inc.

FOR JOAN AND GORDON

CONTENTS

PREFACE

As a photographer, there is a particular view of our landscape which has had great influence over the way I have looked at my country; the view from a train window. From the train one looks at the unguarded side of places, where America is unselfconsciously revealed.

While a train is surely not the only vantage point for such revelation, it is one which is uniquely unobtrusive, if we bother to look at all. When the train stops, there framed in the window is a scene arbitrarily placed there, as far as we are concerned, by the decision of the engineer. We may only see it in one way, as it is presented to us beyond the glass, like a silent movie on a screen. It is a set. No more than the photographer can tear down a pole that is in the way, or add a building that isn't there, can we move the train for another point of view.

But within that limited field of vision, we begin to see things that perhaps we would not otherwise notice. For the most part, what is visible from the tracks is the unceremonial part of town, the most ordinary elements of a functioning community. Because it may be the only thing to see, a lamp post on the platform gains prominence. We notice how many wires and telephone poles there are, we study the intimacies of someone else's back yard, look down an obscure side street in a part of town we might not otherwise notice, or be squarely confronted by a plain white frame house with an aluminum screen door. Even cracks in the pavement and man-hole covers and a group of electric meters on the side of a building become subjects for our attention. A store window is examined in detail as the train waits while baggage is loaded

up ahead. And when the scene begins to slip away from us, imperceptibly at first as the train begins to move, we find ourselves still discovering and trying to hold on to what we have found as long as we can.

But what do we see of our land when we make our own choices? Do we look at much more of our own country than the visitor from abroad who comes equipped with brochures from Thomas Cook and Sons? Is our awareness restricted to the shrines and the breathtaking places — the stations of the cross, in which the Grand Canyon and the Grand Tetons are mandatory stops? Is it to be only the full-color picture book America — the Maine seacoast village, lobster pots and weathered shacks; autumn in Vermont (with or without the white frame Congregational Church), and springtime in the Smokies, winter in the Sierras and the Fourth of July in Kansas, the Golden Gate at sunset bathed in the ethereal Pacific fog, downtown Dallas at night and the Grand Coulee Dam? The great overview. It is the image of America dressed for a ball — a masked ball. The strains ring in our ears: "America the Beautiful," "America the All Powerful," "America the Greatest!"

Or is our vision to be restricted to what we find along the "Heritage Trails" which lead us down the garden path of history to the America of the restorations and the reconstructions? Are we only to give our attention to those places where History, even if just for a fleeting moment, squatted on a curbstone now sanctified with the halo of authenticity? Somehow even if historical significance is only a device for ensnaring one, those places are too often endowed with the aura of being the most American.

We will not discover the look of America in Williamsburg, nor along the lanes of Old Sturbridge Village — nor the West in Virginia City, Montana. Only actors will we find, and a set designed by wishful thinking.

Neat, clean, little Appomattox Court House could hardly be today as it was on the morning of April 9, 1865 when Grant in his mud-spattered uniform galloped up to the little farmhouse where Lee waited to surrender his sword.

The place called Promontory Summit was once so eloquently desolate; a few abandoned buildings and a small stone marker, off in the Utah desert where they drove the Golden Spike. Then it became a National Historic Monument, and all the old buildings and gaunt unstrung telephone poles that marked the route of the first transcontinental railroad were torn down to make room for the new visitor center and a paved parking lot.

Cape May, New Jersey, or what is left of it, has become almost a travesty of itself, and Galena, Illinois, Grant's own home town, perhaps the archetypical American Victorian town,

has been discovered. Now antique dealers, mod boutiques and mock Victorian restaurants are taking over the main street stores. But the back streets, inhabited by the descendants of those who worked the lead mines which gave the town its name, have been spared thus far because they are too ordinary to be of interest. Meanwhile the heart of the town is well on its way to becoming just another tarted-up tourist trap.

To know New England only by examining Portsmouth's Strawberry Banke, the House of Seven Gables and by traipsing through the pristine white colonialism of Litchfield is not to know New England any more than a Garden Tour of the plantations of the Mississippi Delta and Charleston is to know the South. And New Orleans is not just the enclave known as the Vieux Carré.

America is not only the beautiful package that the travel agents and the coffee-table books and the Bicentennial Committees would have us accept; there is yet another distorted view purporting to represent the *real* America. The ugly America, America the profligate, America the land of anguish, of confrontation — sullied by corruption and pollution, a world of ghettos, a place populated only by the downtrodden, despairing blacks and bearded demonstrators, brutal police, a corrupt doomed establishment. A place where the air is foul and the rivers poisoned. A land of litter, and garbage dumps and oil spills. The land of *Silent Spring*. The land of the endangered species. Tragically, all of this is here, and were it not for the continued crusade of a handful of the dedicated we should probably be lulled into believing the coffee-table view and go right on exploiting and plundering the very land we depict as being so beautiful. Thank God for the Sierra Clubs and the Ralph Naders, for the preservation of our Yellowstones and for the Constitution and the Brooklyn Bridge, for they are sources of our inspiration.

America eludes categorizing. It is represented fully neither by the beautiful view nor by the profane. America can only be found in that vast space between the heights and the depths. Not a region but a *place*.

It is a place we all know because it is everywhere, yet its very intimacy often makes it a stranger to our consciousness. We focus our attention on the beautiful things, on our history and our problems, while overlooking what regularly confronts our eyes.

If we look, we see that it is mostly a place that has been put to use by its people. A place

where necessity and expediency have taken precedence. It is mainly a place of practical things, ordinary things like farms and factories, streets with rows of houses, places to worship and service stations for the basic commodities of living. Taken as a whole, the place is rather like an old slipper that has been worn to a comfortable fit.

But if this place is not tangibly spectacular, it is eloquently representative of the people who made it. The product of successively inconsistent evolution, it is a place that has been molded by the ambitions, the failures and needs of each succeeding generation. Here on the face of America, on each street in each town and neighborhood, is the record. The adaptations each has made to his habitat are plainly evident, laid down one upon the other like the sediments in which the secrets of geological history lie, the record of the American evolution. And on the surface is today's topsoil, the organic medium where the everyday processes of life and death are depositing their own sediments.

It is a place of back streets with names like Maple and East Walnut or South Eighteenth Avenue, where laundry hangs out on the line, where there is always the sound of a car door slamming and the engine starting. A place where one hears dogs barking. A place of streets where kids ride their bikes after school, a place where their fathers and older brothers spend Saturday mornings washing their cars. It is a place of quarter-acre plots, the little piece of America that everyone dreams of owning, a place of cherished garden patches and gates which never quite latch properly.

It is downtown too, on Washington or Division or Main. Stores like Kresge's and Skogmos commingle in the same block with L.F. Brown & Sons Inc., Paint & Hardware, est. 1917. At the corner, opposite the new post office built during the Eisenhower years, is the Farmer's and Merchant's Bank & Trust. Across the street is another block of three- or four-story brick buildings dominated at sidewalk level by the plate glass of the newly modernized Olsen & Levine Men's Clothing. Next to John's Restaurant, in whose booths most of the population have sat down for a cup of coffee at some time in their lives, is a doorway where in gold leaf is written the names of the firms whose offices are "Two Flights Up." The facade above the street looks much the same as it did when it was built as the Howard L. Ingram Block — 1887 — except for the oversized signs of the establishments below which occasionally intrude between the windows.

Further up the street is the movie house; the Beacon, or maybe it was the Capitol. Across the way is the most imposing building in town, the Union Hotel (although it could just as easily be the Plainsman or the Antlers, depending on the locale). A six-story yellow brick

affair which boasted the first elevator in the county when it opened in 1914 at the height of the "boom" before World War I. Since then it has been modernized several times, each time under new management, most recently during the neon era. Like others of its kind it has fallen on hard times lately. The convenience offered by nearby motels on the edge of town has slowly eroded its steady supply of transient clientele — the salesmen and those who came on business to the Tool & Die Plant down on River Street. Even the Kiwanis and the Rotarians have forsaken its high-ceilinged dining room for the Coliseum Motor Lodge. Today the top floor is occupied by the studios of the local radio station. There are no more wedding receptions, nor do local candidates any longer kick off their campaigns there. Instead, old men sit like fixtures on the hotel's worn leather chairs staring into the street from the oversize lobby windows.

Behind the desk in the office, below an electric clock, is an old safe with UNION HOUSE in ornate gold lettering painted on its door over an oval painting of an elk. From behind there too, a radio plays against the silence which is accentuated all the more by the sound. The wall behind the desk is dominated by a calendar depicting a snowcapped mountain and lake, entitled *Autumn Tranquillity* which is there with the compliments of the Barlow Oil Co., Plumbing and Heating. "We've kept you warm for half a century." Accompanying the calendar on the wall are a Trailways bus schedule and a directory of local churches and a flyer for the County Fair announcing that it will be held this year on September 1st, 2nd, 3rd and 4th.

Down past the police station are the Elks Club and the American Legion Post, named for some local hero, a sergeant or a corporal. A little beyond, the structure of the town begins to disintegrate. Here the street, instead of being a part of downtown, has become the route for getting into and out of town. It is no longer a place where one is induced to walk. Here one becomes dependent upon his car and here the places that provide all the necessities of automobile life begin to replace those that provide the human ones. Yet here are still found the established places, like Robertson Motors, which has the local Pontiac and Olds franchise and has been repairing just about anything else with wheels for three generations. But the Robertsons of the street are among the last strongholds of the individual. Beyond, the town quickly peters out. The miscellany takes over, a tangle and jumble of nondescript buildings hidden behind the trademarks of the things they sell.

The nationally advertised, the coast-to-coast world has replaced the local. It's Goodyear, MacDonald's and Carvel, not John's Restaurant. Colonel Sanders is here too, his beaming face atwirling in the sky on a giant plastic bucket of Kentucky Fried Chicken. This is the world of the drive-ins-and-outs of Gulf and Texaco, and the Diner's Club.

Just outside the town limits is the shopping center so recently carved out of the cornfields and whose chain stores are the predators that kill off, one by one, those down on Main.

Beyond stretches the road that leads out into the farmland, whose only companion is often the string of telephone poles, a fence line or a railroad track that parallels it for a while.

Out here accelerating down Route 18 where the addresses are R.F.D. Hillsboro or Rte. 2 Chester is, in another way, the place of man too. The signs of civilization are almost everpresent in the land. A place where the objects themselves, like the radio playing in the hotel lobby, accentuate the scale of the land itself, where one becomes so much more aware of space and emptiness for the distant barn or windmill. The structures are not lost among themselves but stand out against the sky, like the grain elevators that mark the next town ahead and then the next town ahead and then the next, all the way across western Kansas and into Colorado. It is a place where white clapboard farmhouses with green shutters and long porches sit under shady maples in New England and upstate New York, red brick ones behind tall white pines in Ohio, or where sunbaked split-level ranch homes lie surrounded by plowed ground. Places where the kitchen is the center of life, where the fields are still when the men are there having their noonday meal. Where the front door is used only for company, and where barns even if they are unpainted seem more important than the houses.

This place is, as well, the homestead in Oklahoma or east of Havre, Montana, abandoned in the thirties when the bank foreclosed; not because the family didn't try hard enough, but because no one then knew that 160 acres is not enough to make it on the Great Plains. And it is sometimes an abandoned bank building too.

It is where a town can be no more than the place where two roads cross. Where there is just one building, a two-pump gas station which is also the only post office for a radius of fifty miles, and where you can always buy a Hershey Bar and a card of Eagle Claw fish hooks. It is also a service station beside Interstate 94 in Wisconsin, or the wooden parish church which stands empty all week beside a section road until the single service at 10 o'clock Sunday morning.

It is dusty, treeless Main Street of Hazen, North Dakota, with its tin covered stores and brick bank building where wheat farmers in bib overalls bring their wives to town in their Ford pickups.

It is all of these places and more.

What is commonplace along R.F.D. 2 is not the same as in Jersey City, nor in South St. Paul. To those in Youngstown or near Kitty Foyle's part of Philadelphia or the satellites of

Detroit, the familiar would more likely be contained in streets of two, three or ten family houses all jammed together, where on summer nights the steps and streets are the province of men, young and old, tired and noisy. From open windows above, you can hear the sound of squabbling rising over the TV.

In the day it is a street of women with shopping bags who stand for twenty minutes talking in the middle of the sidewalk, and young mothers with their hair up in curlers wheeling their babies in squeaky strollers and stopping to chat among themselves. A place where, unless there is a strike in the mills down by the river, the only men in evidence are the postman or the driver for United Parcel making a delivery, or perhaps a pensioner slowly making his way to the corner store to pick up his newspaper. After school, boys play stickball in the street, contemptuously ignoring the traffic, or stoopball against the high steps. On Saturdays in the spring there will be weddings — occasions which bring everyone out to watch the bride, like an angel, descending the stoop to the rented black Cadillac waiting in the street. Several blocks away on the steps of St. Ignatius, a soot-stained Romanesque building which hovers over the neighborhood like a mother hen over her brood, await the groomsmen in their white dinner jackets.

It is also the bars and the Polish-American clubs further along the same streets near the steel mills. And it's the mills themselves and the factories beside the tracks.

All too often it is the tangled confusion or the carelessness and indifference of Kearny, New Jersey or the south side of Chicago.

As a whole, side by side, one upon the other, all these parts of the place form the most representative American "archeological" site. Here are expressed the values and the priorities which have motivated our most fundamental daily functioning. Just as our daily dress expresses our being more accurately than what we wear to church, so do the tangled, undressed small streets reflect the truth of our experience better than the ceremonial and self-conscious rectitude of broad avenues. What we find on the corner of Main and Elm typifies what most of America is like better than what is on the Park Avenues or the Grand Army Boulevards.

They are not apt to be heroic structures nor conscious works of art. If they do happen to possess some kind of inherent majesty this is incidental, for they were designed mostly to be used and not to elaborate or inspire. The best among them are like the working man who

finds that the most efficient way, the best position to assume while performing a task, just happens to be the most beautiful as well. So it is with many otherwise prosaic structures: a barn, a grain elevator, or a bridge; there is beauty by the same logic. Our daily architecture expresses few fantasies, reflecting instead something close to the real nature of the people who built it.

However, architectural history, like all history, is the same as the continually receding view one sees when standing on the rear platform of a speeding train. The train is time, the track ahead is the future, and where we stand is the present. The view that spins out from beneath us becomes the past as soon as it is seen. The immediate foreground on either side is too blurred by speed to be more than just visual chaos, but as it begins to be seen in perspective, only the most outstanding, the most dominating elements, are able to withstand the diminishing effect of distance — and thus imprint themselves on our memory. The rest along the wayside is lost. But those things which are so typically American are rarely those which rise high enough to be seen from the speeding train on the horizons of history.

Even the study of domestic architecture, a field only recently thought worthy of attention, is confined to the houses of the great and the "well-to-do," behind black iron gates or high hedges up on the hill along Prospect Avenue. Those across town, down on the north end of Water Street, those that Bernard Rudofsky would call "non-pedigreed architecture," like the people who live in them, are left out of the chronicle.

The Water Street houses, the average farmhouse, in fact the places where most of us have lived, are often diminished by the critics as being no more than "carpenter's" houses. And many of us must be conscious of the voices of derision, embarrassed perhaps by the plainness of our houses, and so disguise them with pretensions. Out of place, out of style, out of scale additions of the wrong period are so often used in a hopeless attempt to make a cottage into a mansion. Ironically, those on Prospect have also felt the need to copy established respectability and so have borrowed from Tuscany and the temples of the Greeks or from the Second Empire for their palaces. For both those on the hill and on the street, the urge to modernize, to keep up to date or gain distinction has usually resulted in the destruction of whatever architectural integrity their houses might have had in the first place. But the "vernacular" has suffered the most. "New stone" has been slapped onto the row houses of Baltimore and aluminum grill work facades to the storefronts on Main Street. Comfortable bracketed verandas have been sacrificed for more lawn, that especially absurd status symbol wholly incompatible with much of the American climate. In effect, most of our best native archi-

20

tecture is being overwhelmed by the same standardization that is threatening to wipe out the very diversity and regionalism which has been the basis of much of our culture.

I venture to say, however, that the historian should dwell upon the landmarks even if they aren't truly representative of most of our architecture. Today there is a tendency to over-romanticize the common forms — just as many a New Yorker expects to find a philosopher in every cab driver. No more than each bottle dug up on Friday night and sold to the next Sunday's trade should be passed off as an antique, should the majority of anonymous architecture remain more than just that. The real importance of the vernacular lies perhaps in its symbolic values, even if it does not always have intrinsic ones.

What I find in the places I photograph most often — the commonplace, ordinary structural environment of America — are all the same paradoxical elements we find in our own democracy. It is like a mirror of ourselves, a synonym, a confessional, an embodiment. The elements are all there to be seen in almost any town in America: on the streets of Bucyrus, Ohio or Marion, Kansas or Danville, Vermont, or Coxackie, New York, or Clarion, Iowa.

Here houses and stores, gas stations, barns, churches and bars, buildings of different styles and times, parking lots, telephone wires and signs all stand inside the political framework of the municipality. Yet within it, unless it is a planned community like Pullman or Reston, there is hardly ever any visual or architectural compatibility among the individual elements. It is plainly evident that no one hand arranged them, that there was no master plan, just the dictate that it was useful or necessary for them to be there. It is almost as if these clumps of buildings had sprung from windblown seed and now compete with one another in an uncultivated garden.

It is this very randomness which makes these places, these buildings, so characteristically American. Here is all the unregulated individualism and lack of discipline, all the diversity of heritage, all the conflicts, from which have come both our nation's strength and its suffering.

But it is true that this same random eccentricity, which has wonderful visual dissonance along Main Street, can also run rampant. Too large a part of that familiar daily world of ours expresses nothing but debilitating chaos. Often there is simply too much visual competition and so we turn away, ignore it rather as we did mainland China for so many years. The presence that wasn't there simply because we did not want to admit that it was. However, too little argument, whether among individuals or buildings, leads to boredom. We ourselves deplore the idea of regimentation and yet we have already — and quite willingly it would seem

— acquiesced a larger part of individual freedom than is necessary for a functioning society. Even from a strictly visual point of view it is obvious that too much of where we live already reflects a drift toward a deadening totalitarian conformity. All one needs to do is look at the rows of houses in the developments, as alike as cars in a Ford dealer's lot, or at the urban housing projects that are replacing the neighborhoods of cities. "They take the heart out of us," one old Italian lady told me who had spent most of her life in one of those "slums" in East Yorkville before she was relocated to a project in the Bronx.

Whenever we seek to impose a uniformity or an artificial organization upon the land or upon the people, we put in jeopardy those very institutions which we cherish so deeply and from which come a large measure of the richness of life that has nourished and inspired us.

It is that middle ground, between the hill and the tracks, that ordinary, disorganized, commonplace world of plain existence, which speaks most eloquently of these paradoxes and conflicts. Here the buildings are not immortal any more than the individuals who use them. As structures, they are clearly subject to the same frailties and idiosyncracies as ourselves. Regardless of scale, they are not architectural celebrities among us, nor do they intimidate us with pretension as do those that we proclaim to be symbolic of our democratic institutions. They simply share our lives, reflect our lives, rise and fall, succeed or fail as we do the same.

THE PHOTOGRAPHS

Whitman County, Washington: 1973

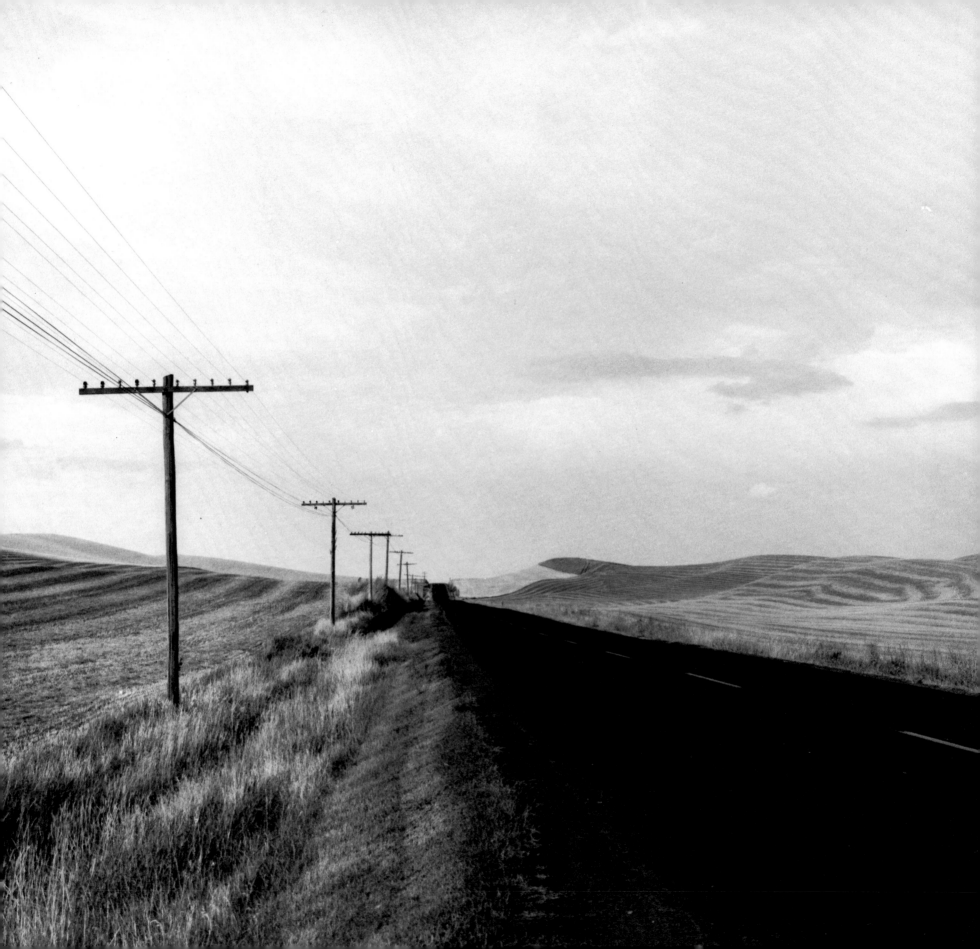

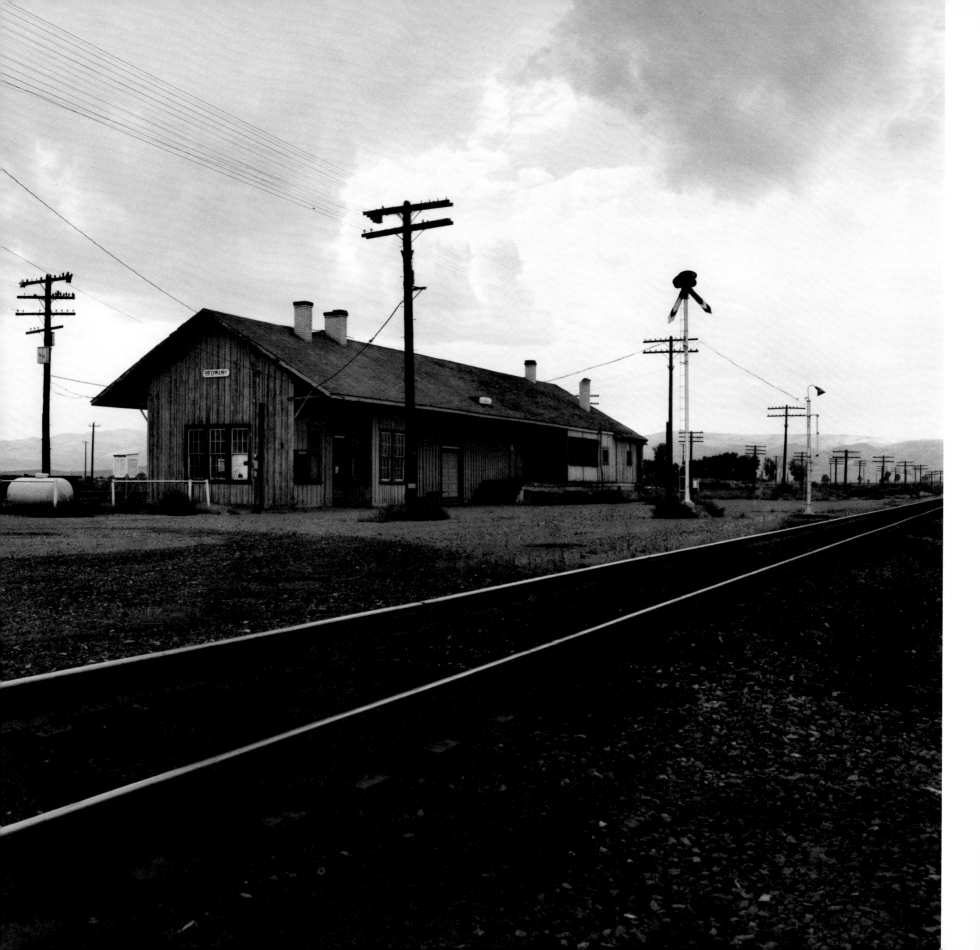

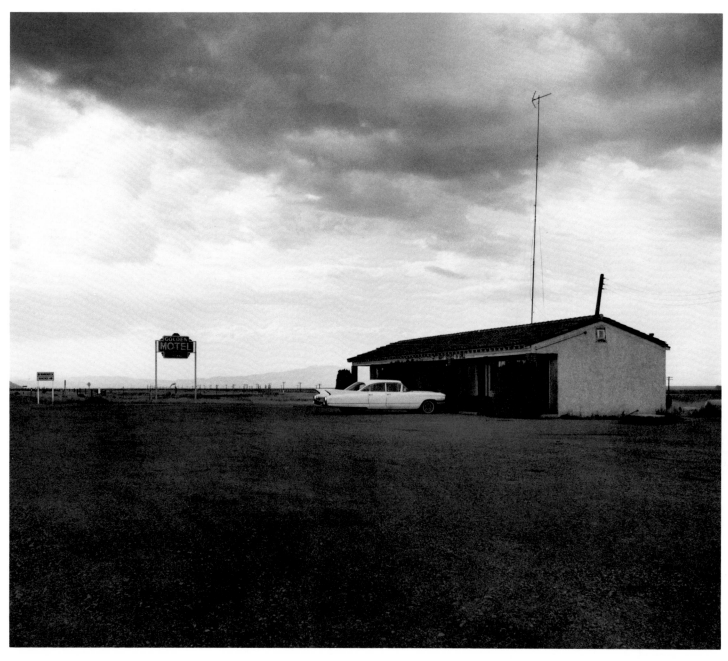

Beowawe, Nevada: 1973

Valmy, Nevada: 1973

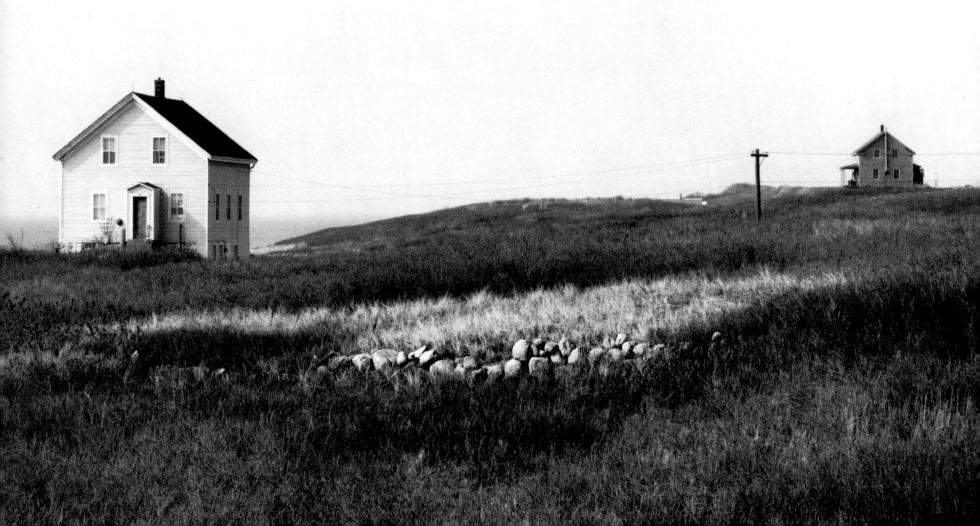

Block Island, Rhode Island: 1973

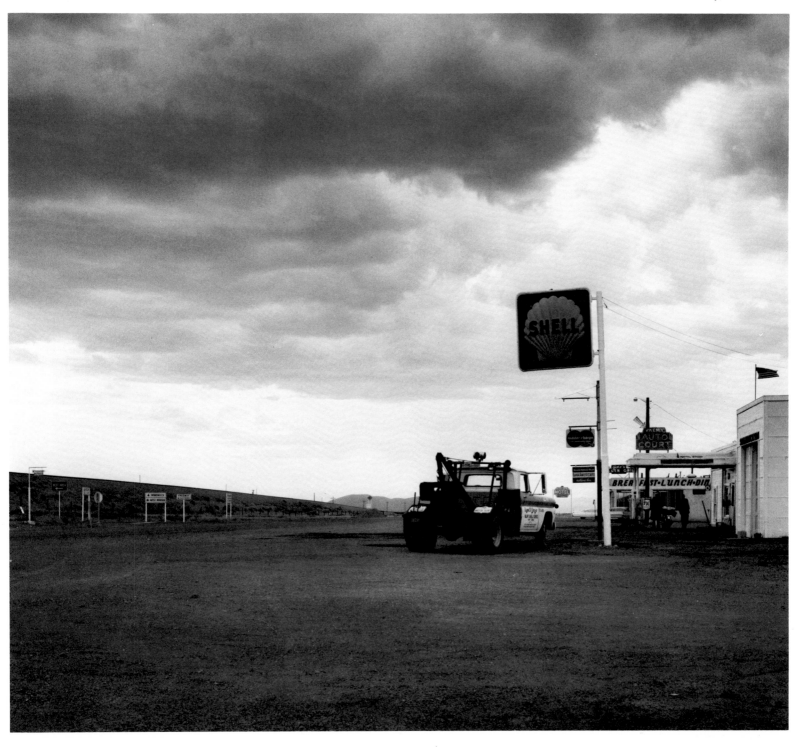

Putney, Vermont: 1964

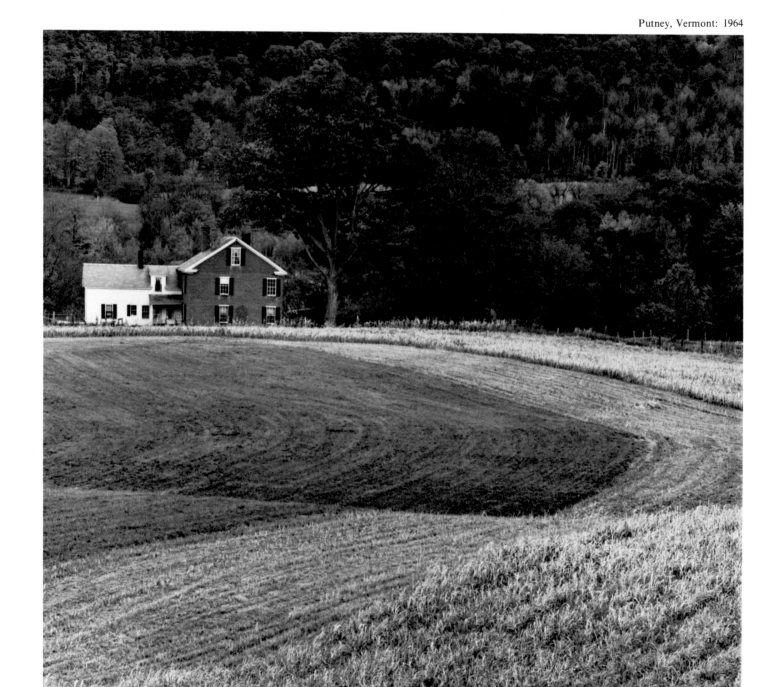

30

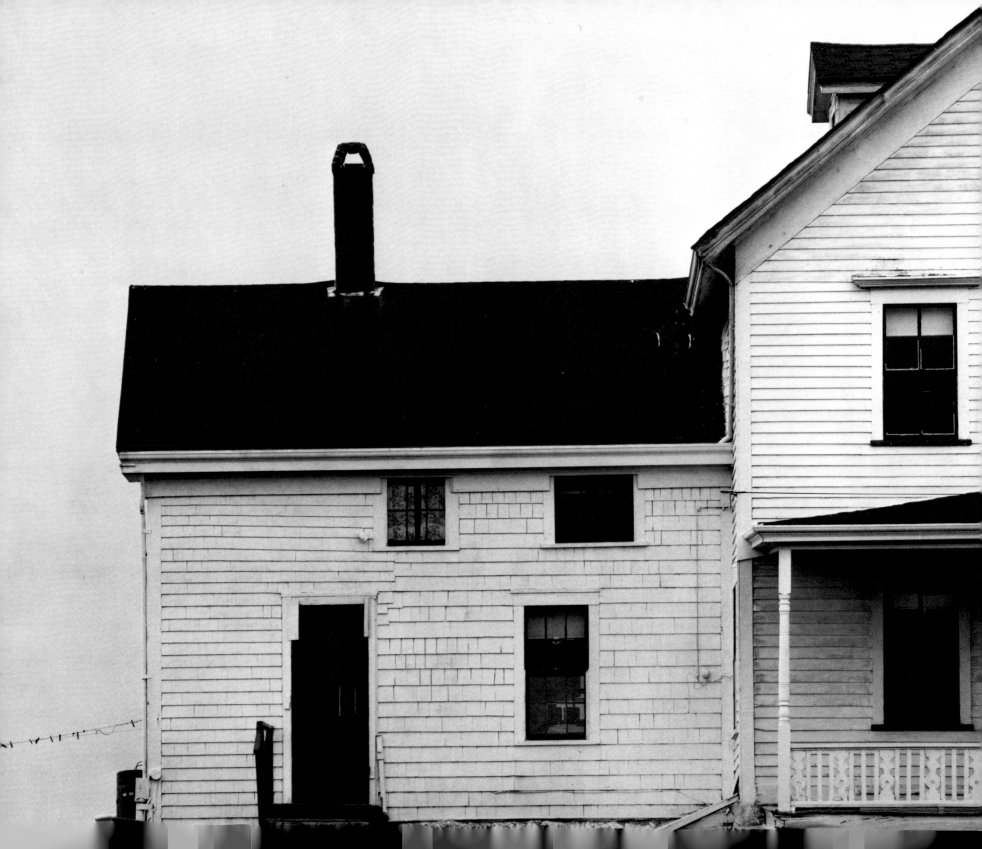

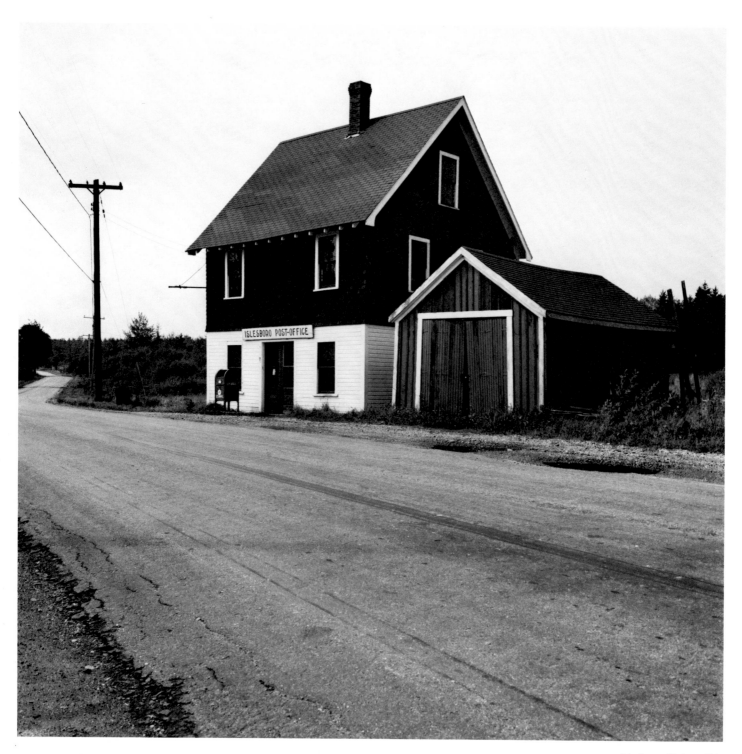

Islesboro, Maine: 1966

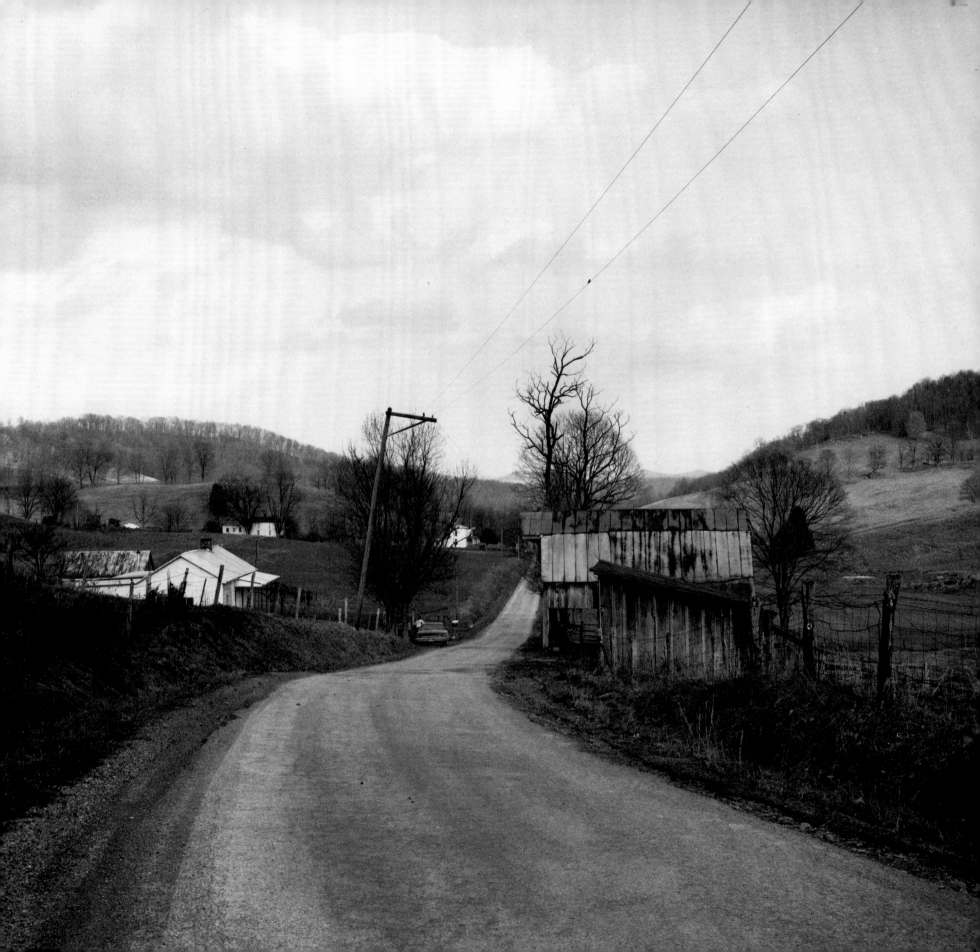

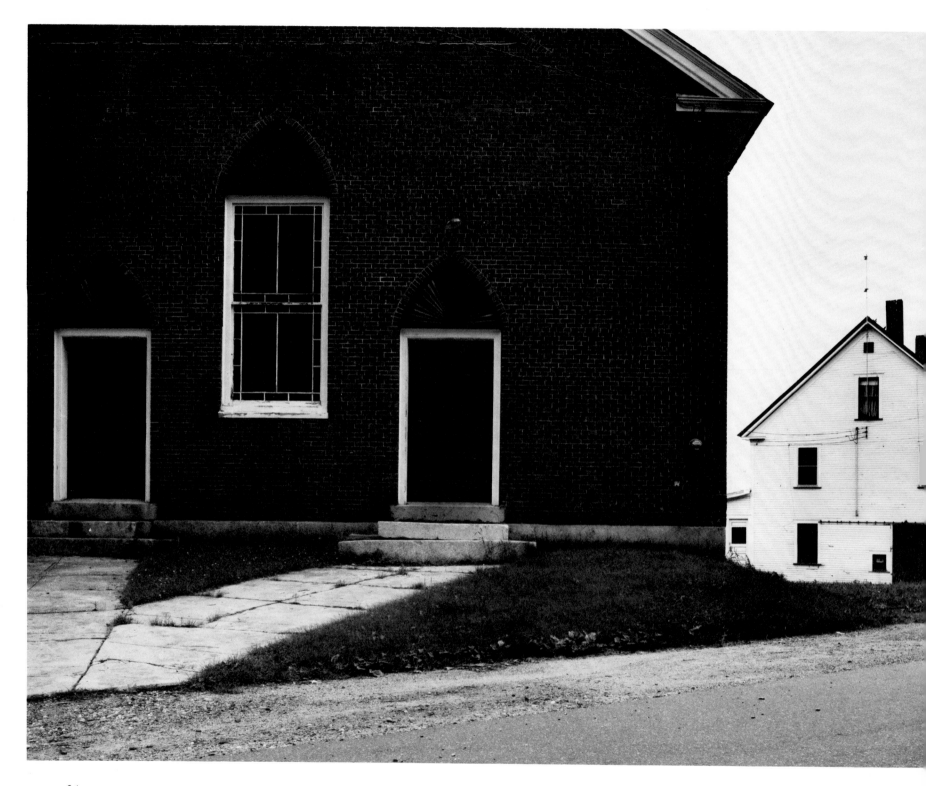

34 Danville, Vermont: 1973

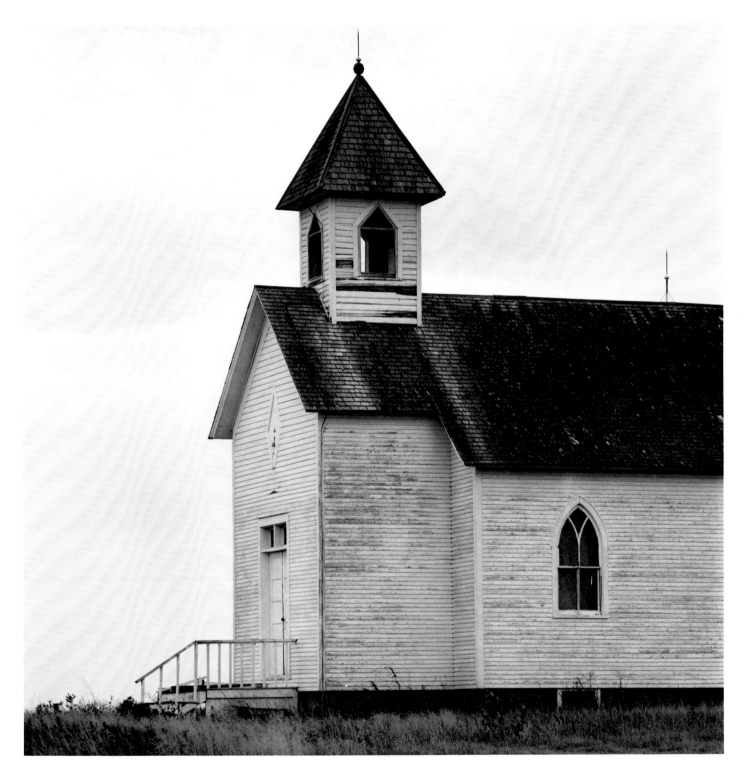

(near) Red Cloud, Nebraska: 1971

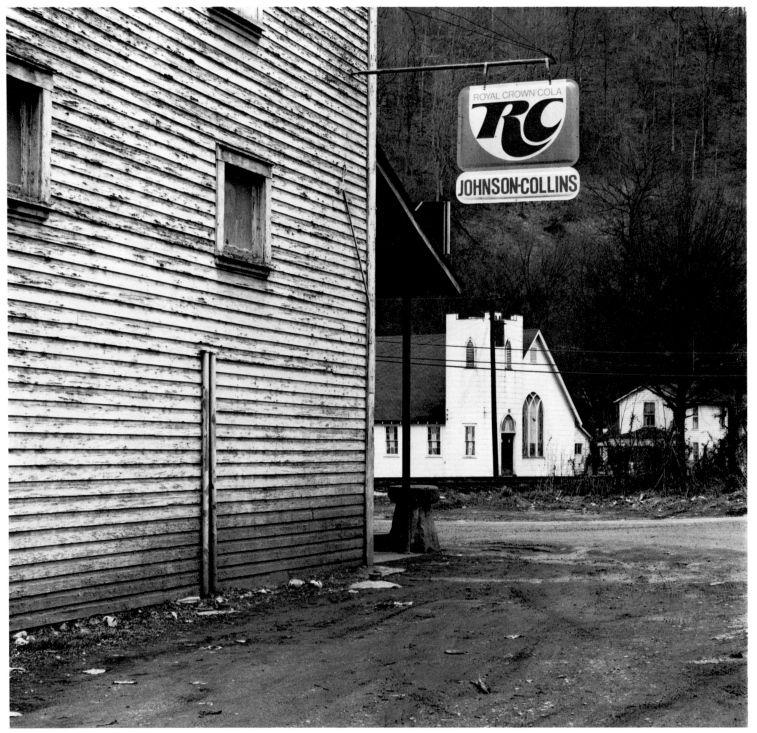

Millstone, Kentucky: 1974

Midland City, Illinois: 1973

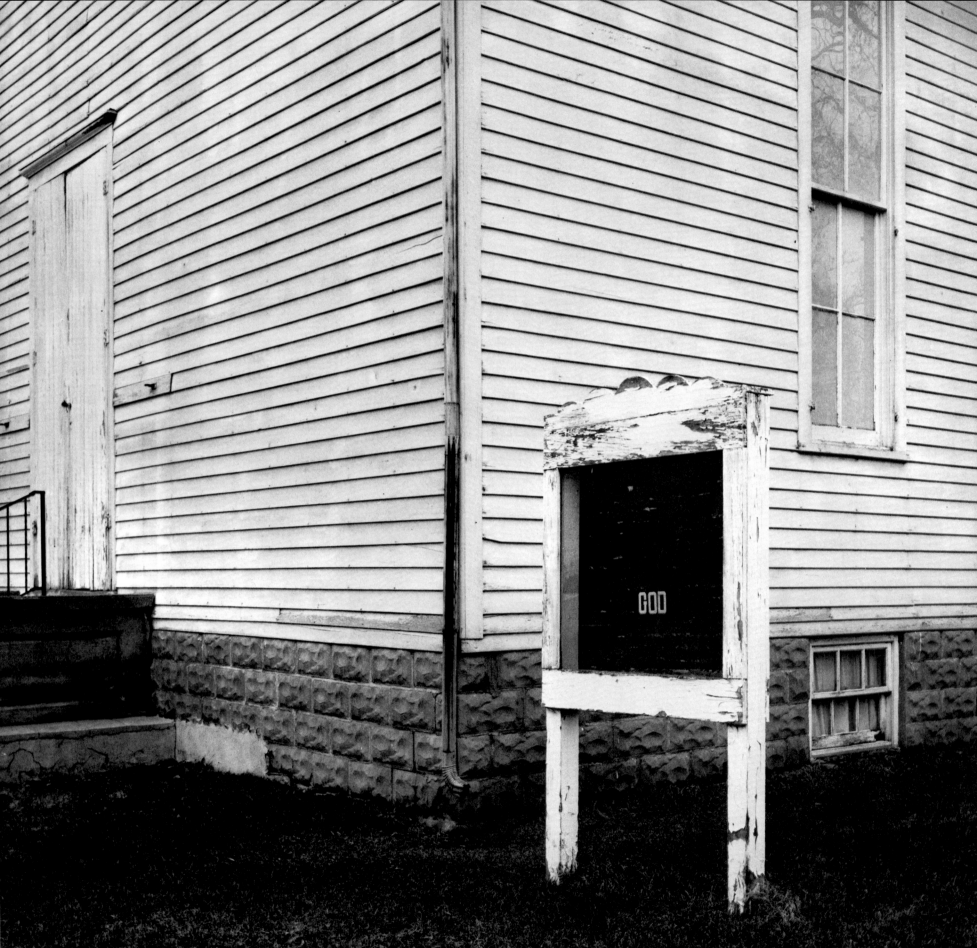

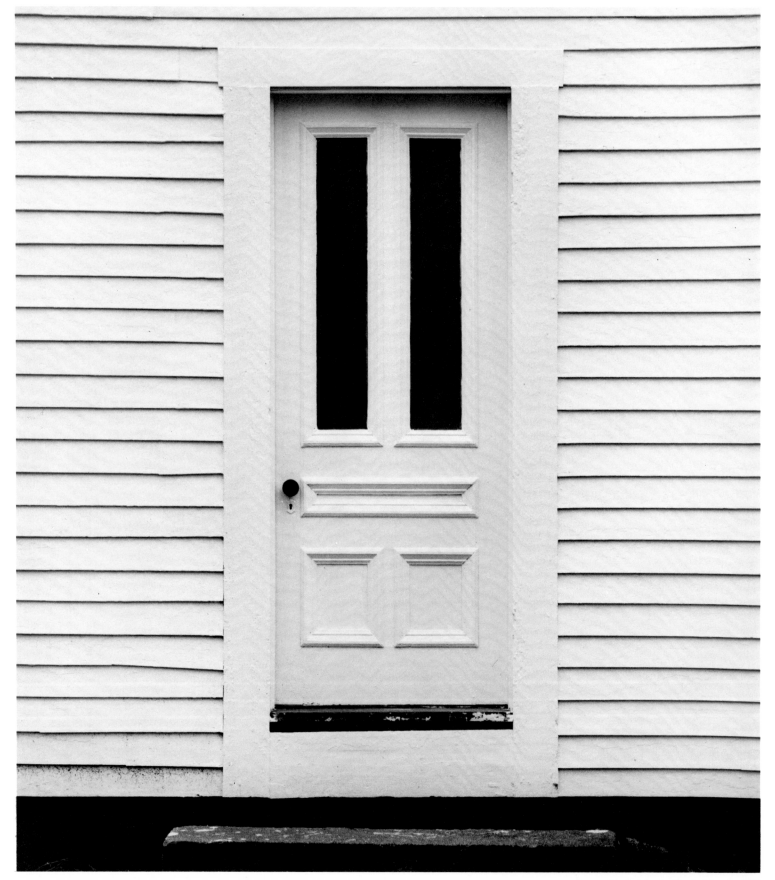

38

Block Island, Rhode Island: 1973

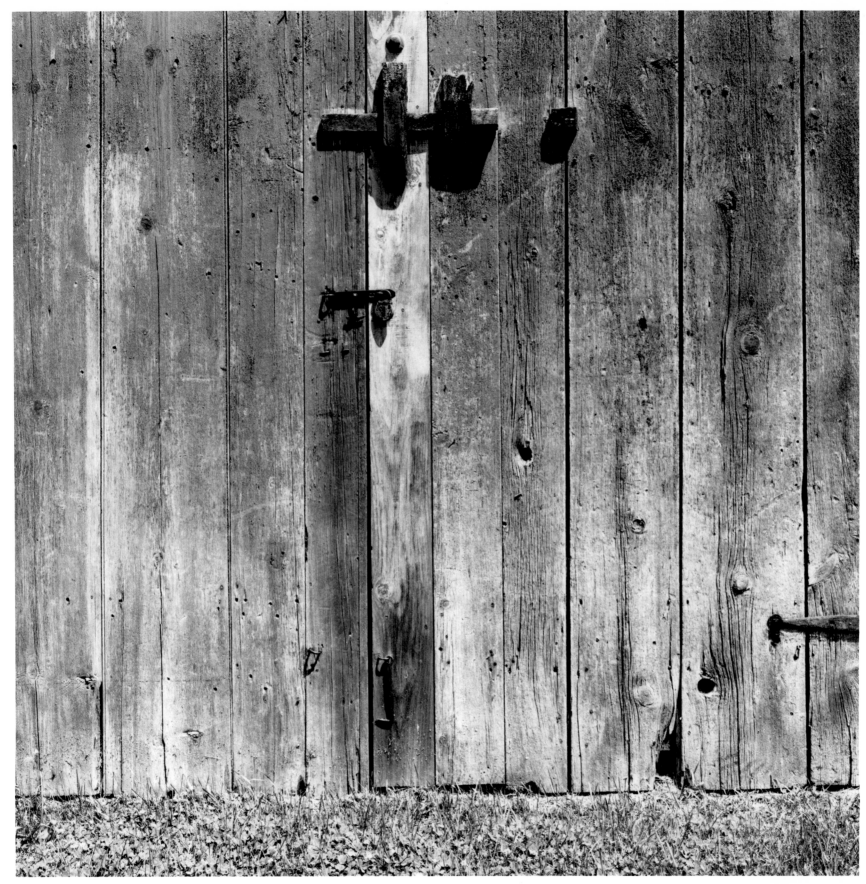

Newcastle, Maine: 1972

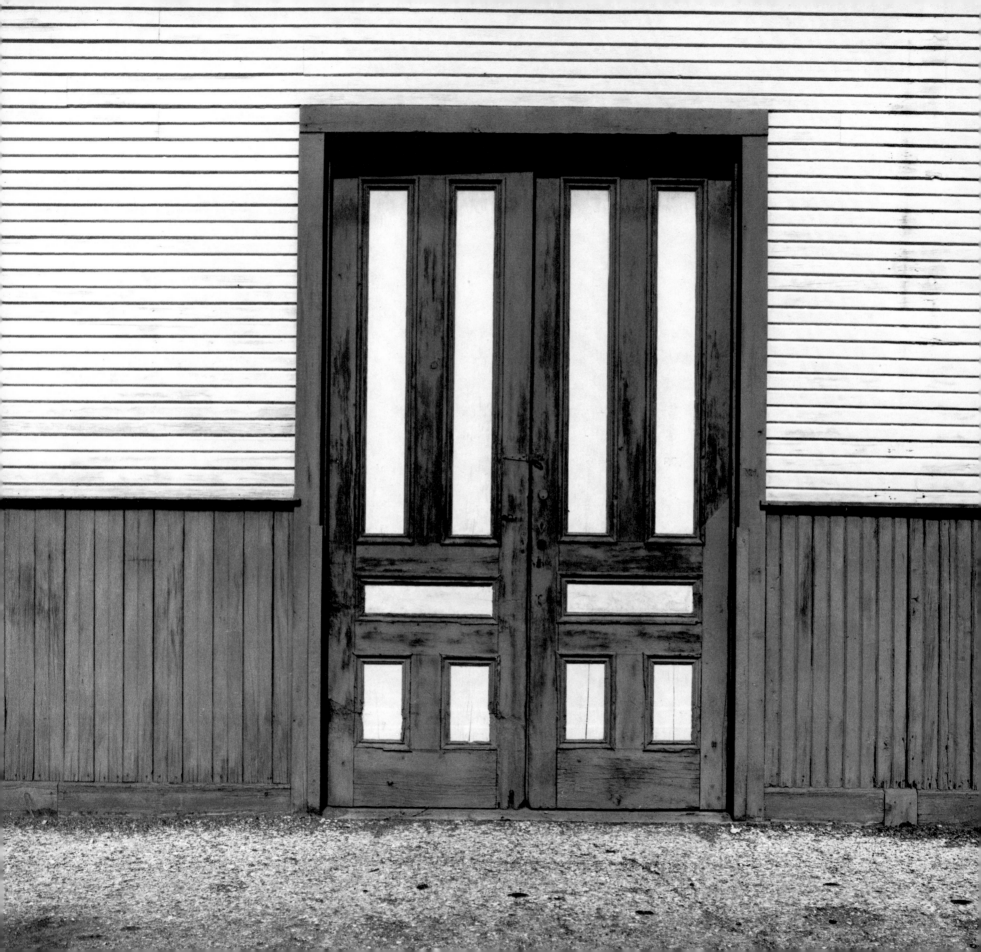

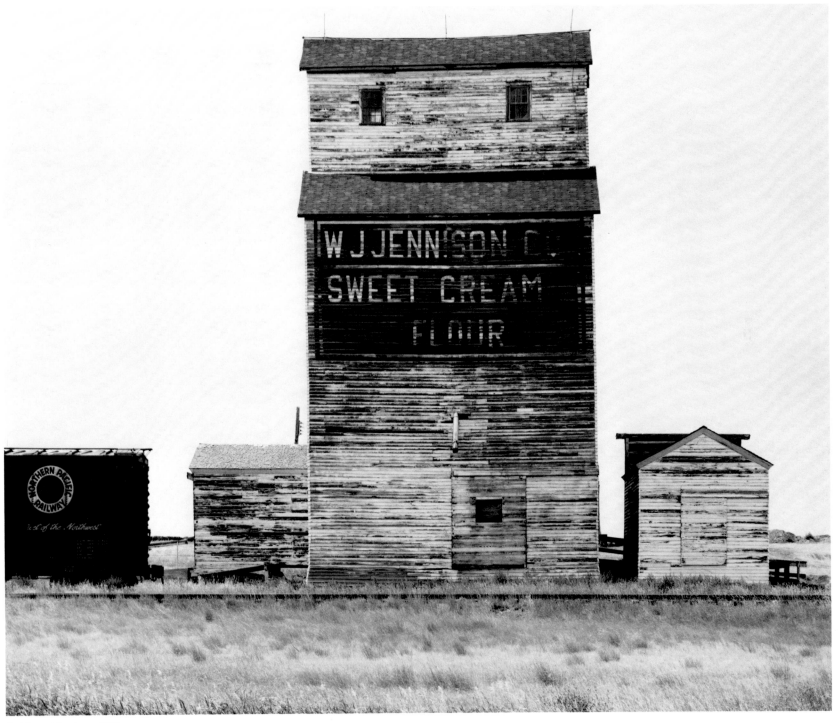

Antelope, Montana: 1971

Falls Creek, Pennsylvania: 1966

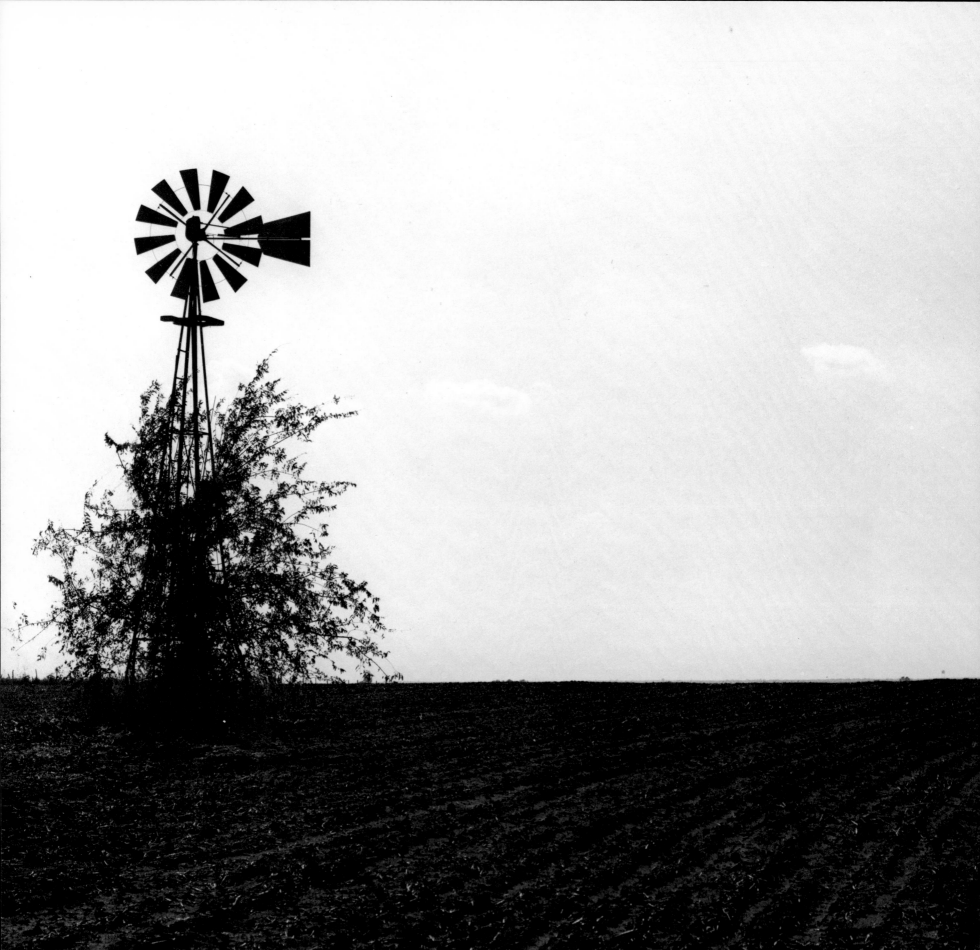

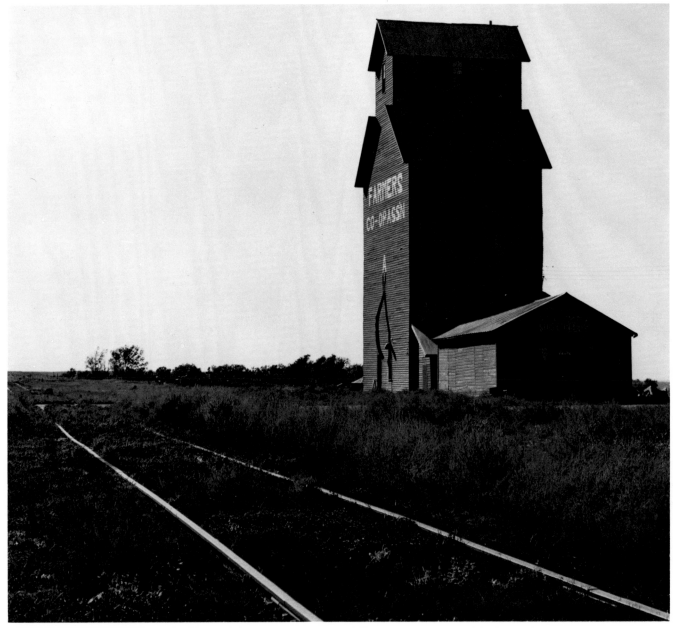

Dallas, South Dakota: 1969

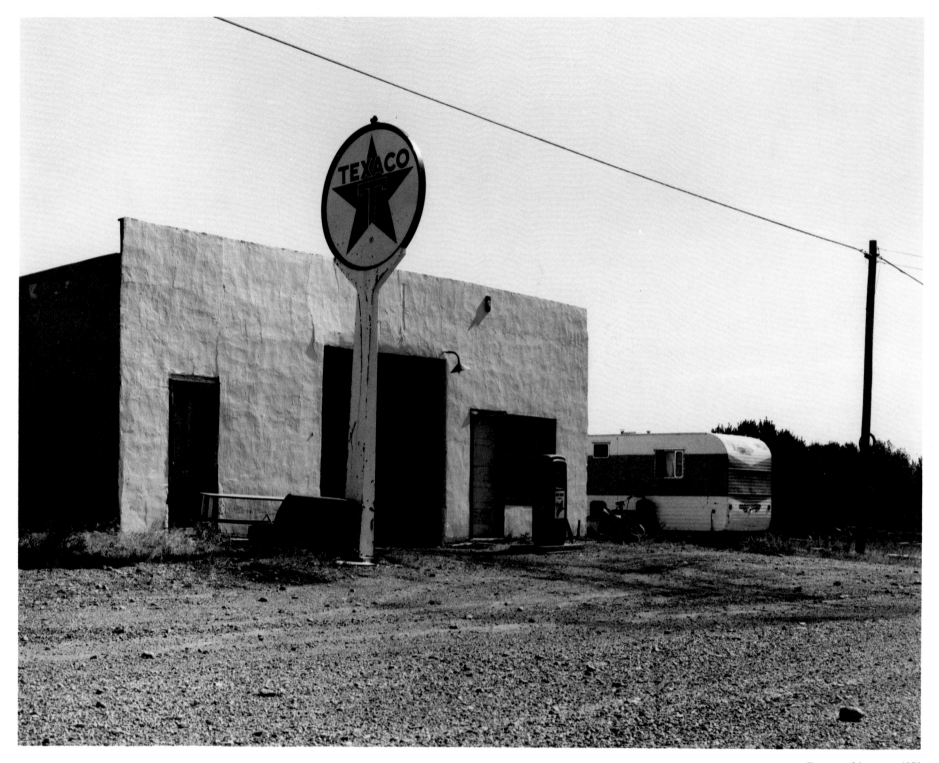

Zortman, Montana: 1973

Falls Mill, West Virginia: 1974

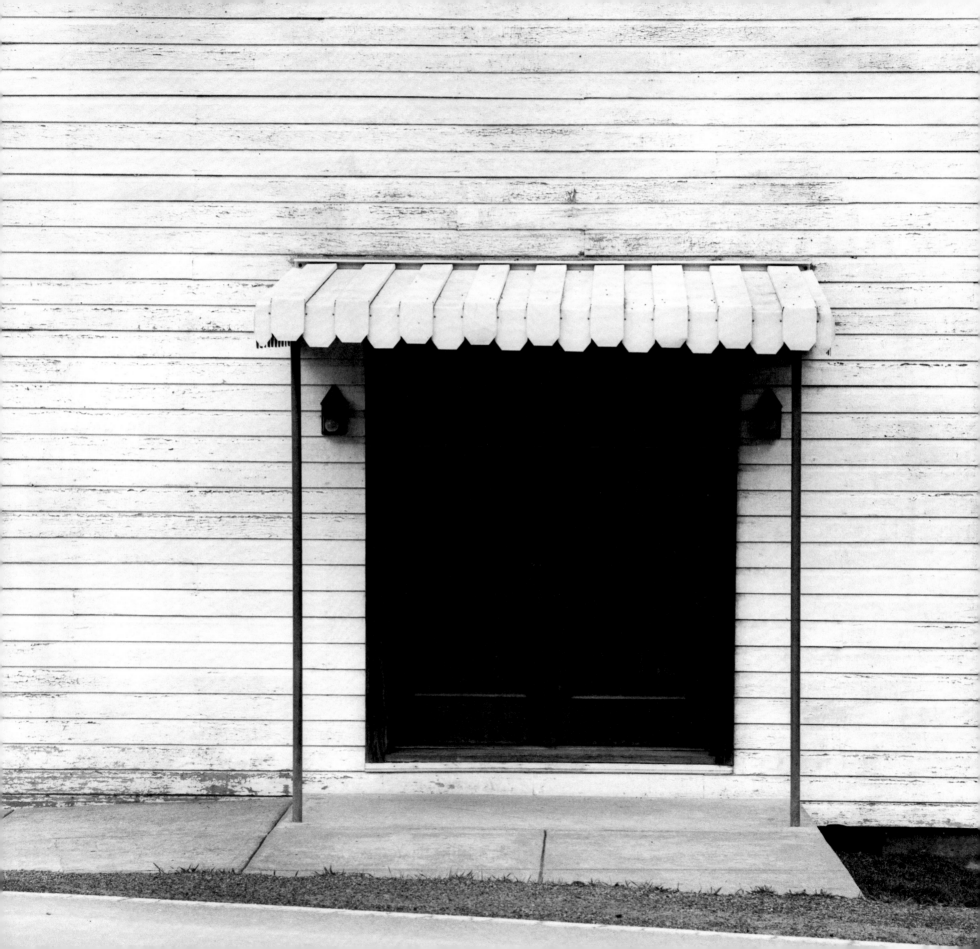

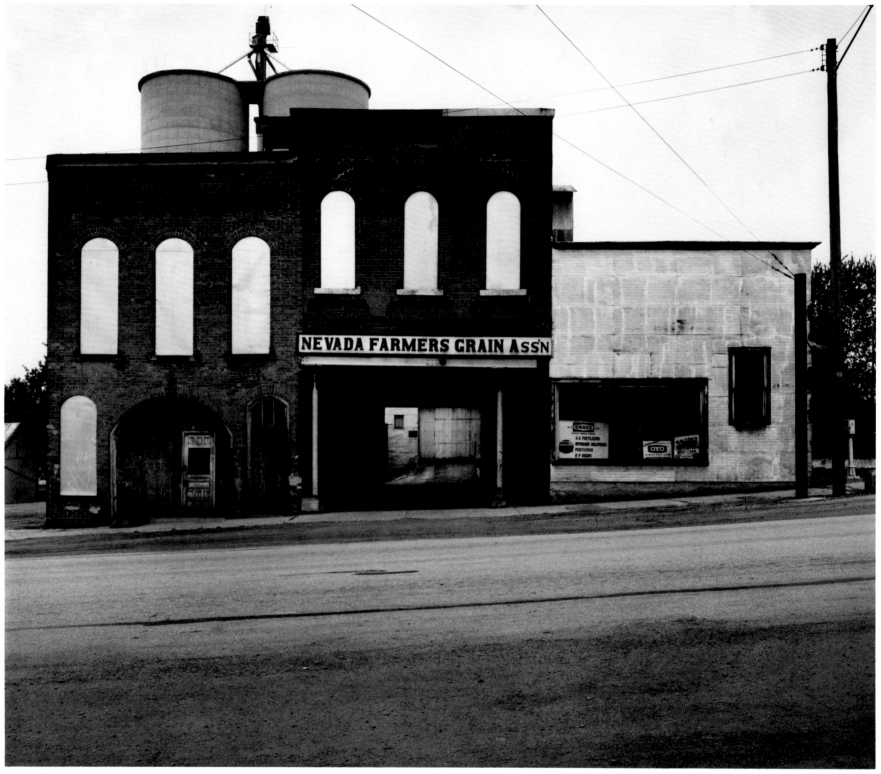

46

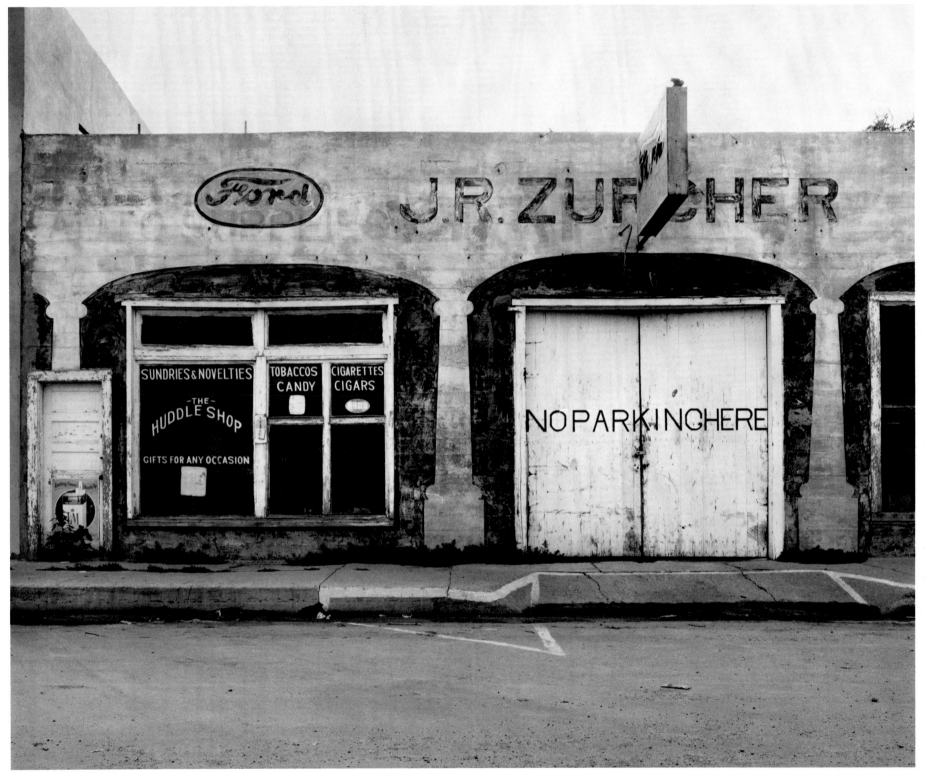

Stratton, Colorado: 1973

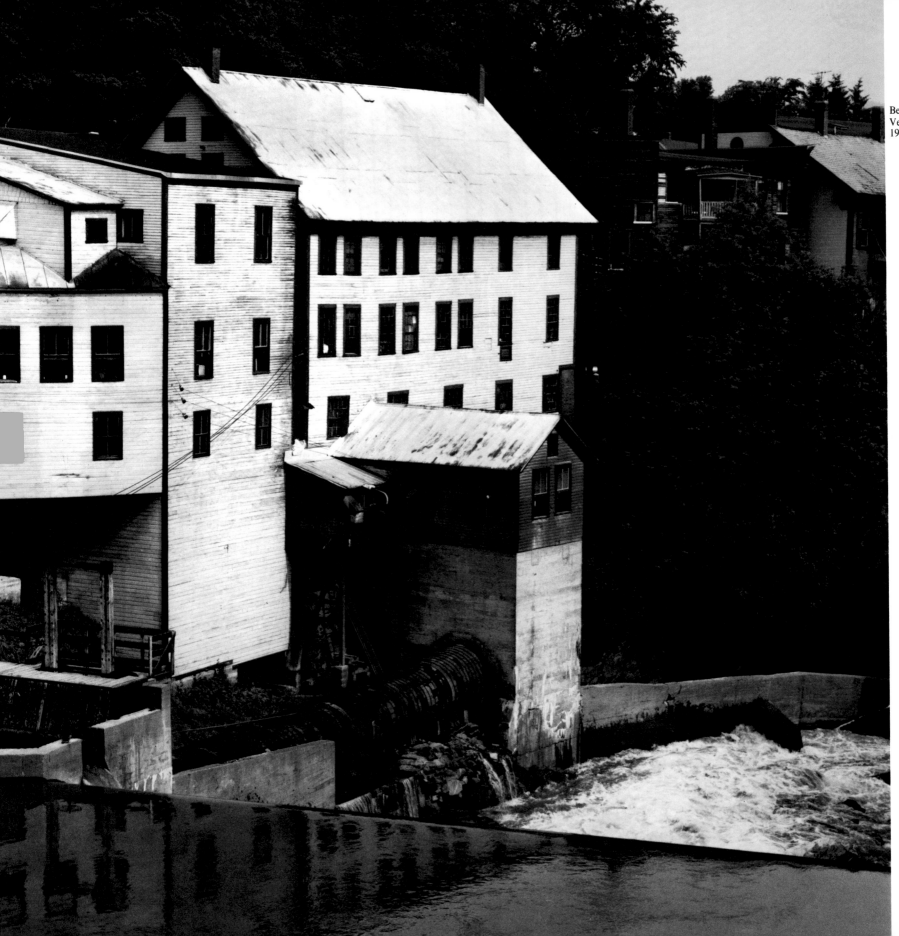

Bethel,
Vermont:
1973

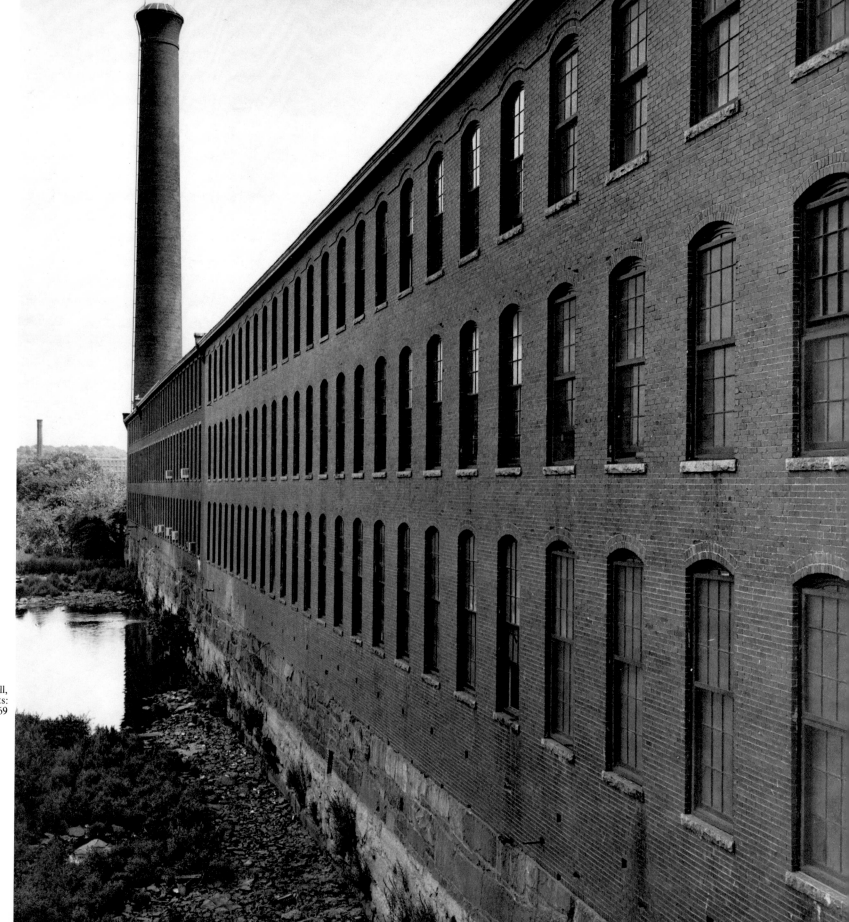

Lowell,
Massachusetts:
1969

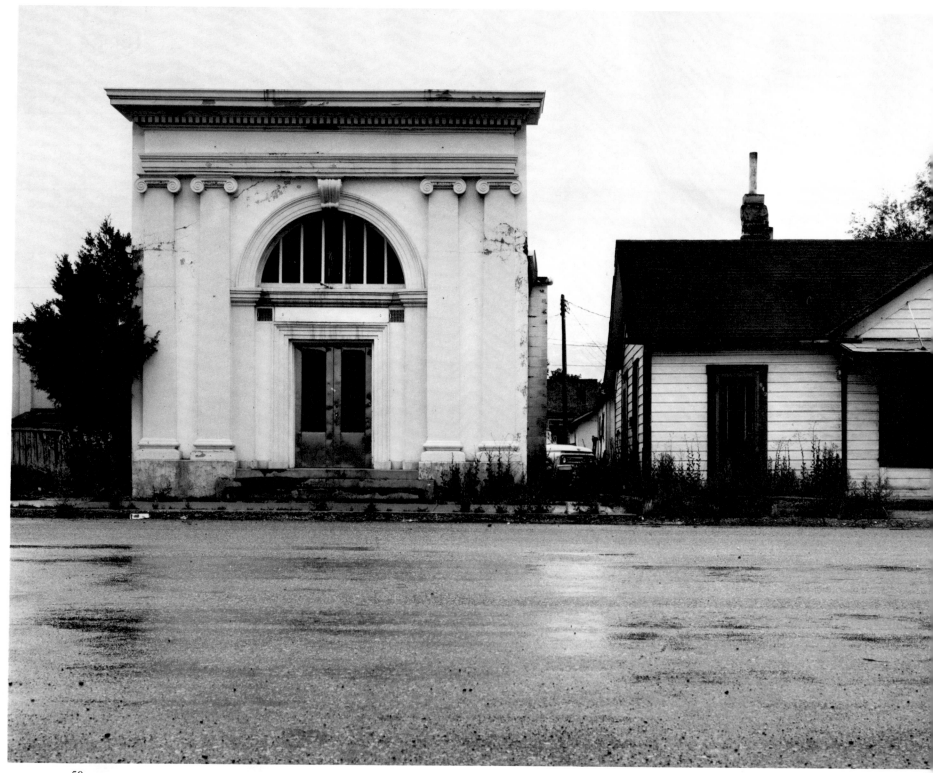

50

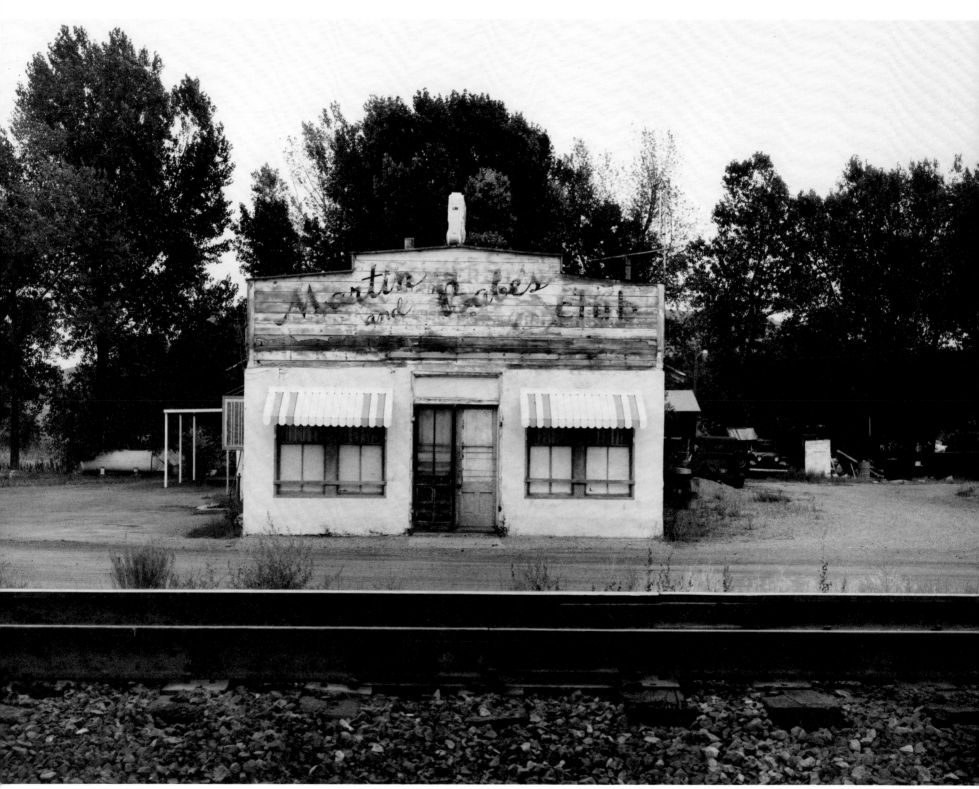

Beowawe, Nevada: 1973

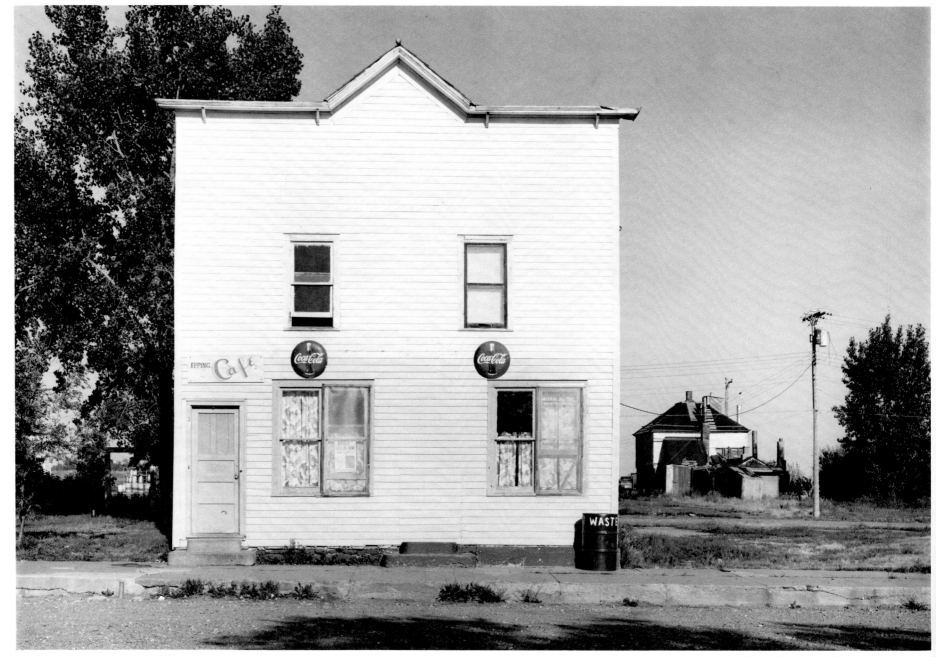

Epping, North Dakota: 1973

52

Culbertson, Montana: 1971

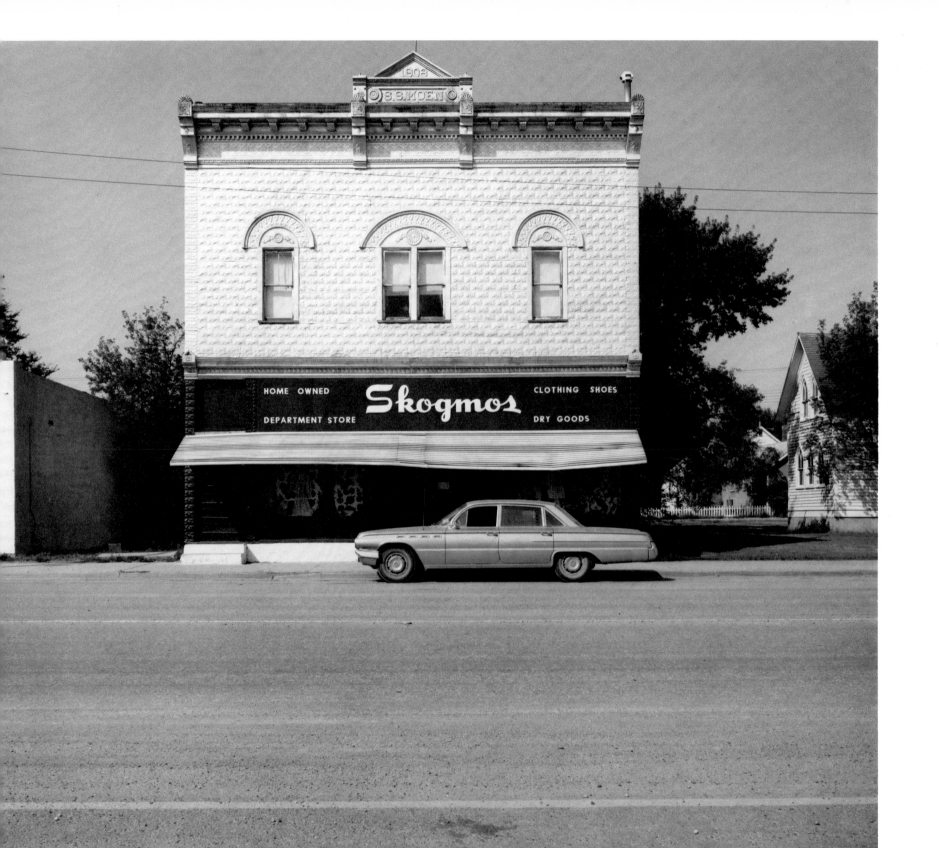

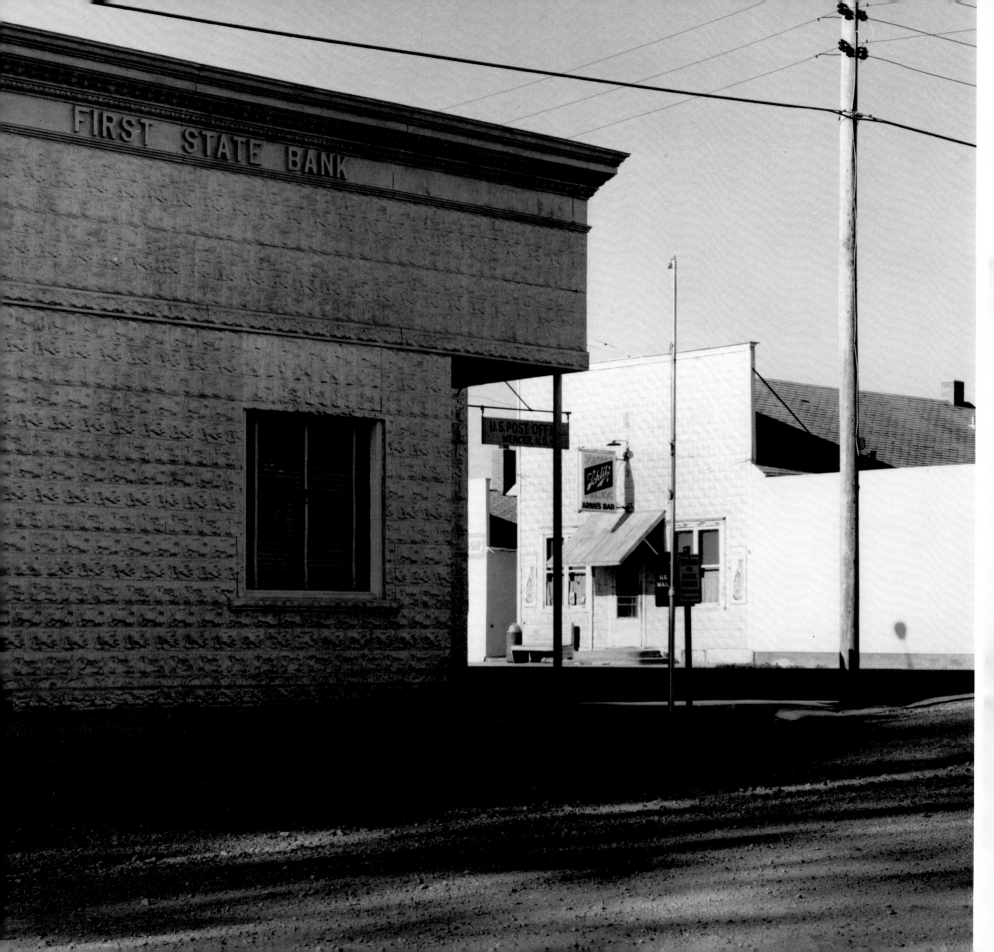

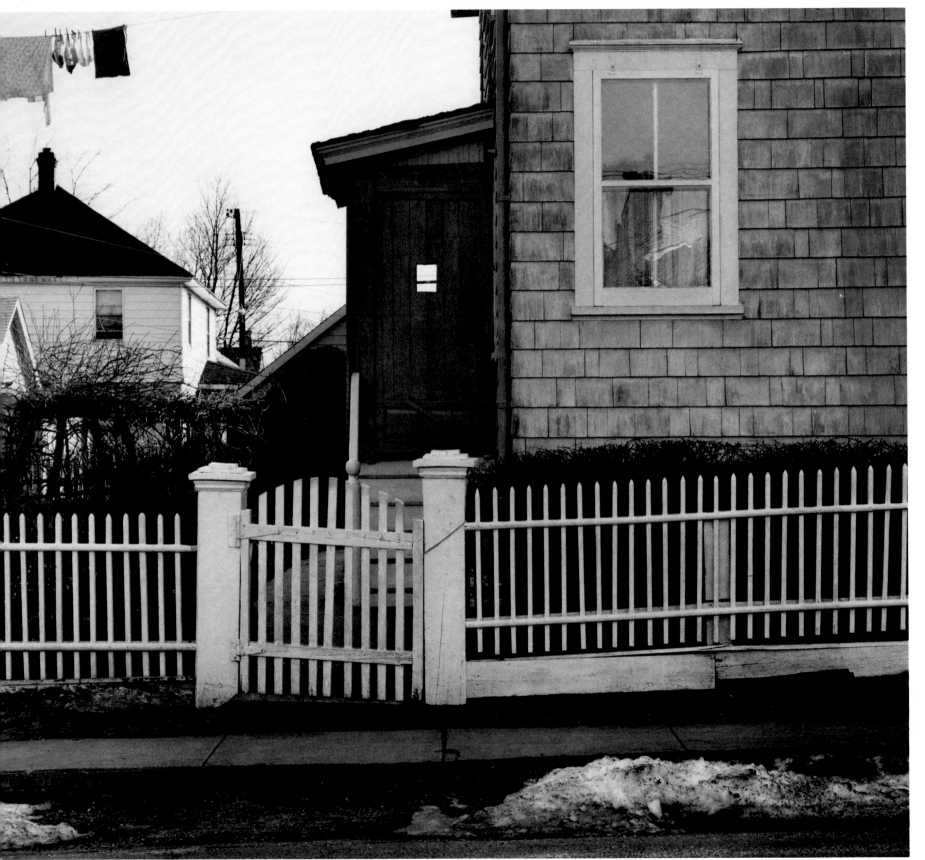

Glen Cove, New York: 1974

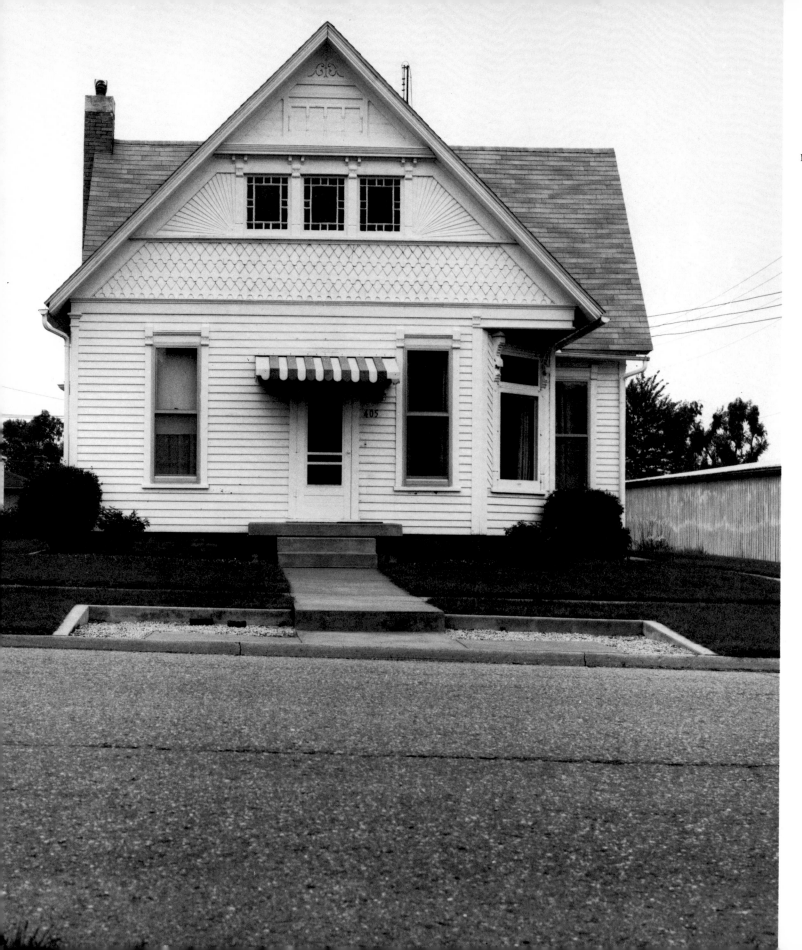

Mackinaw, Illinois: 1973

Sea Cliff, New York: 1974

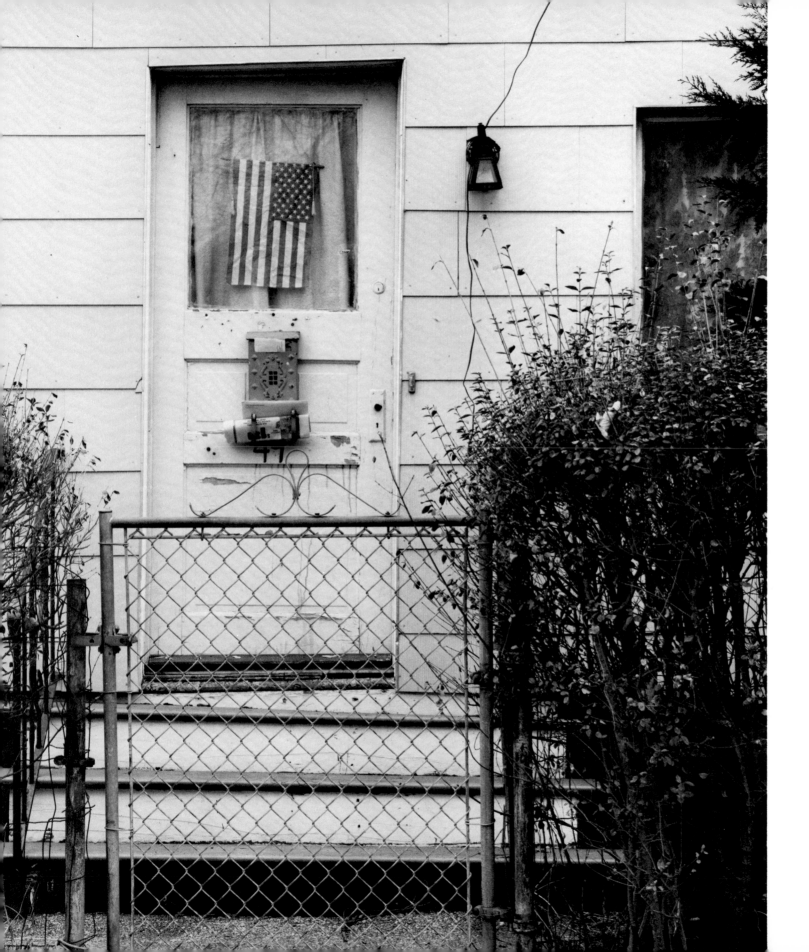

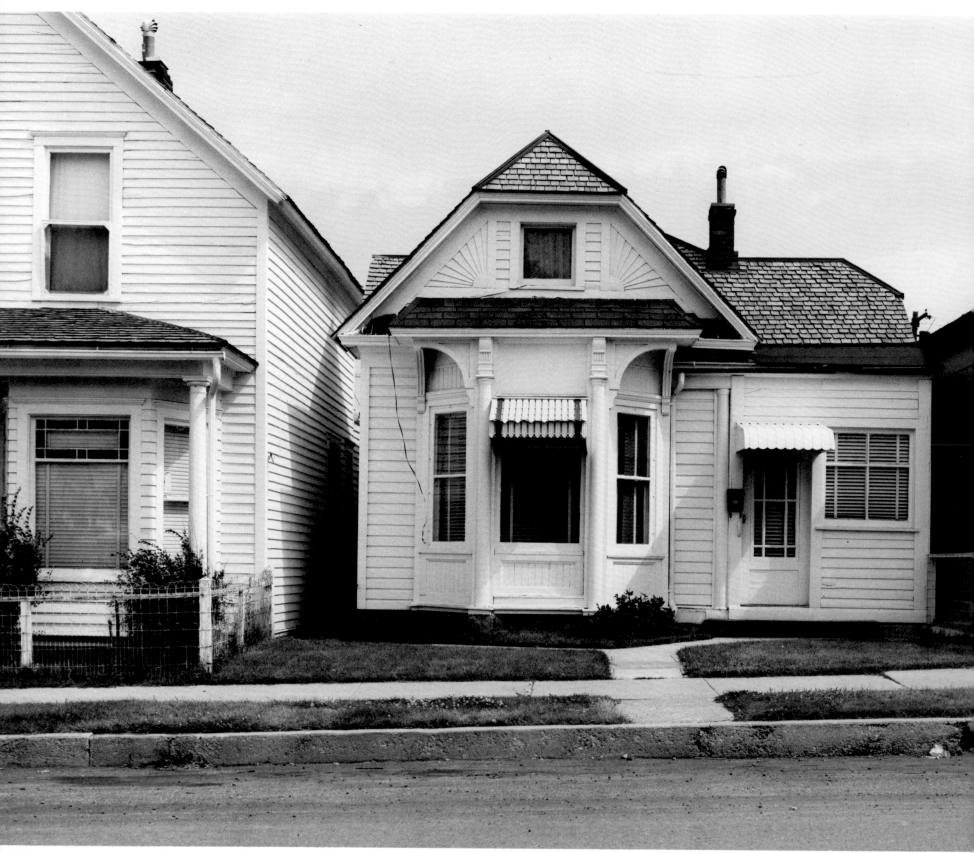

Anaconda, Montana: 1973

Anaconda, Montana: 1973

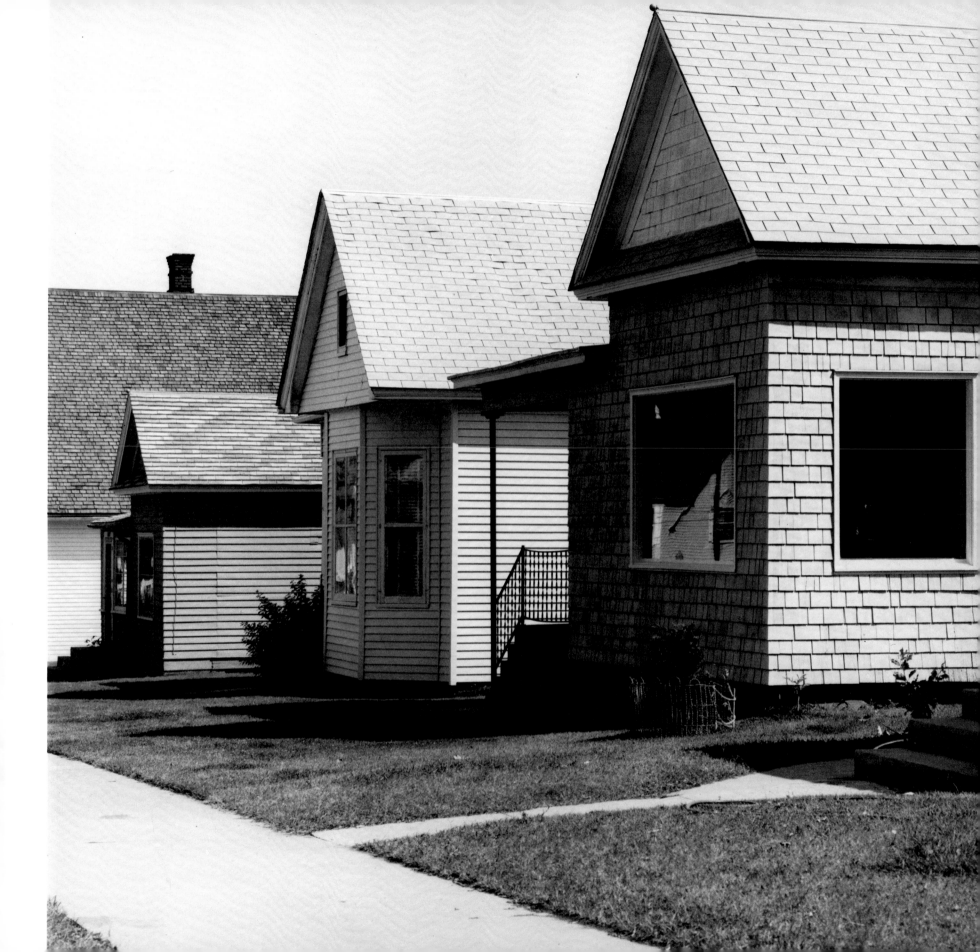

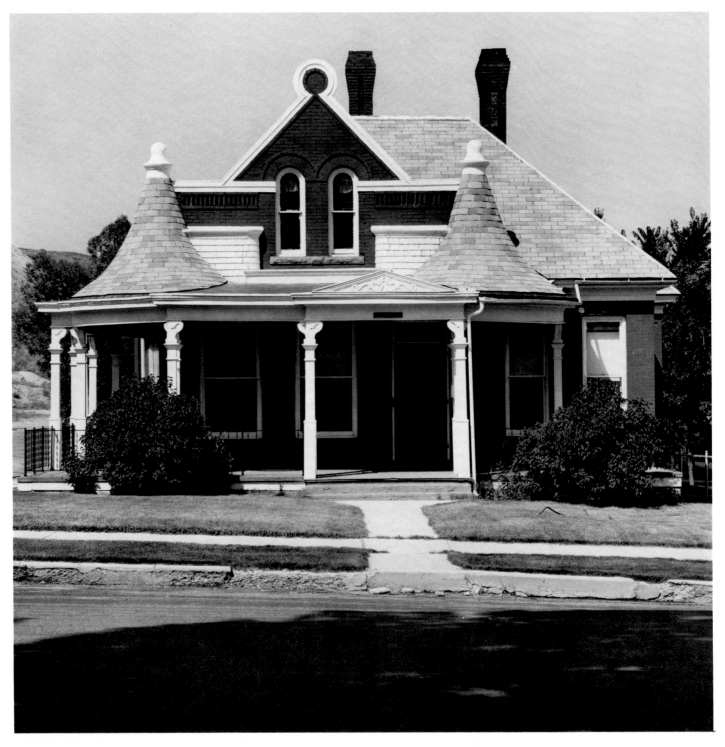

60 Anaconda, Montana: 1973

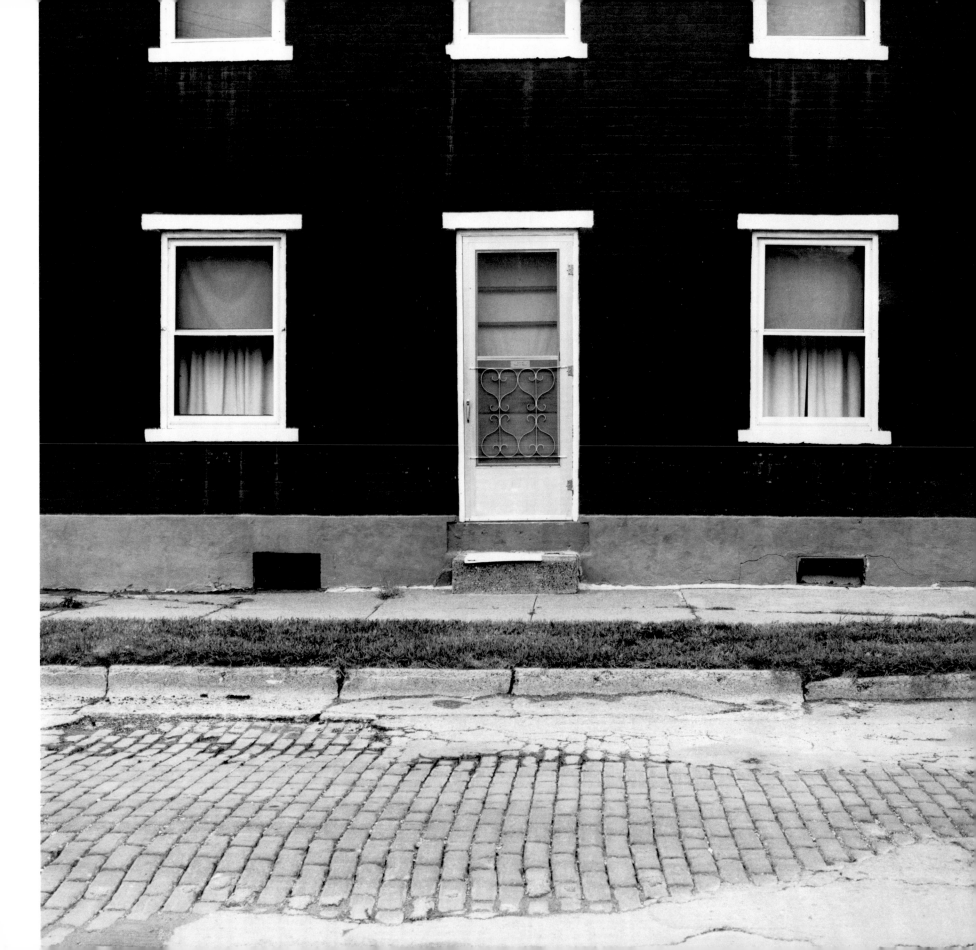

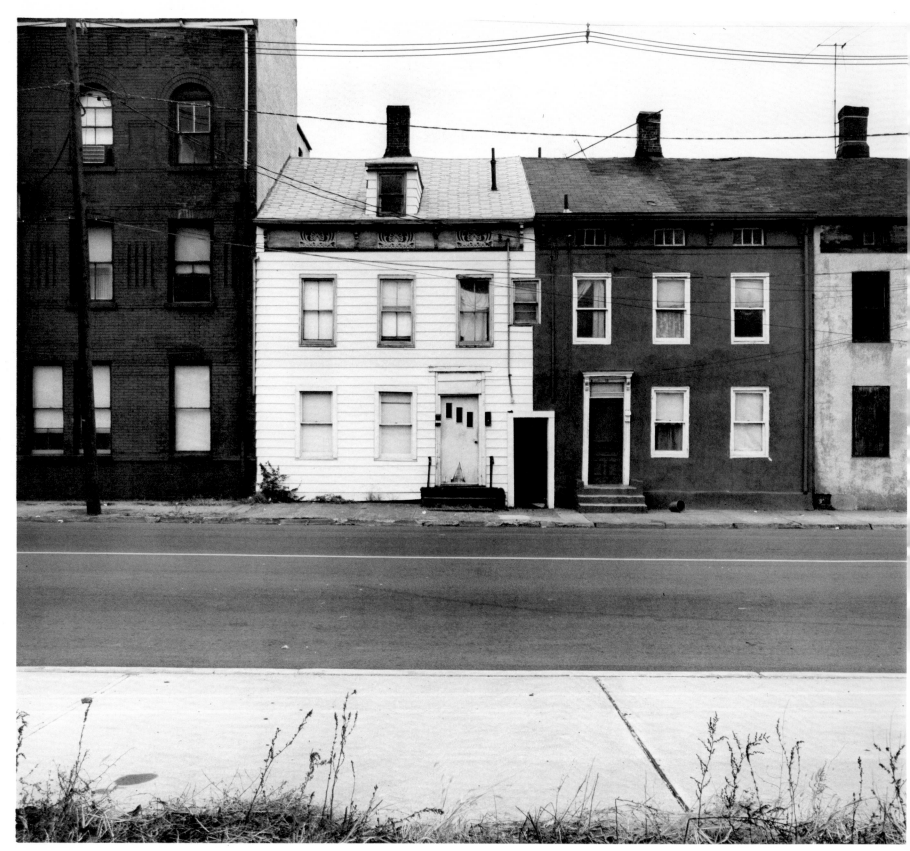

New Brunswick, New Jersey: 1973

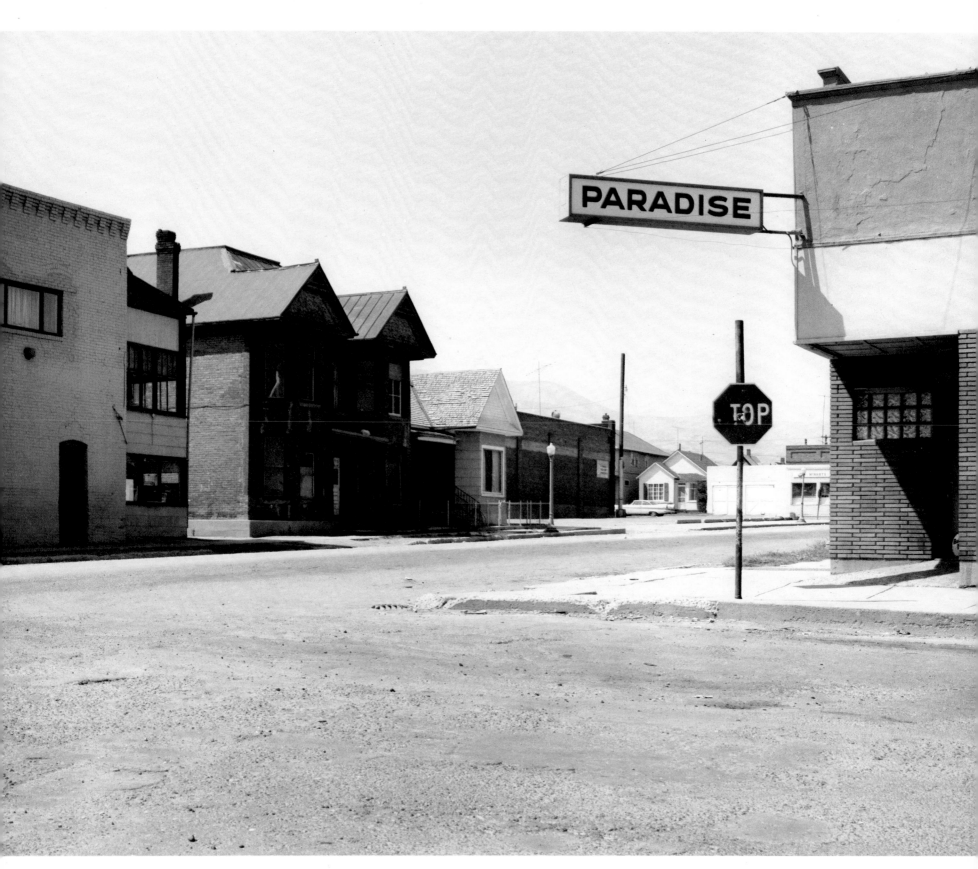

Anaconda, Montana: 1973

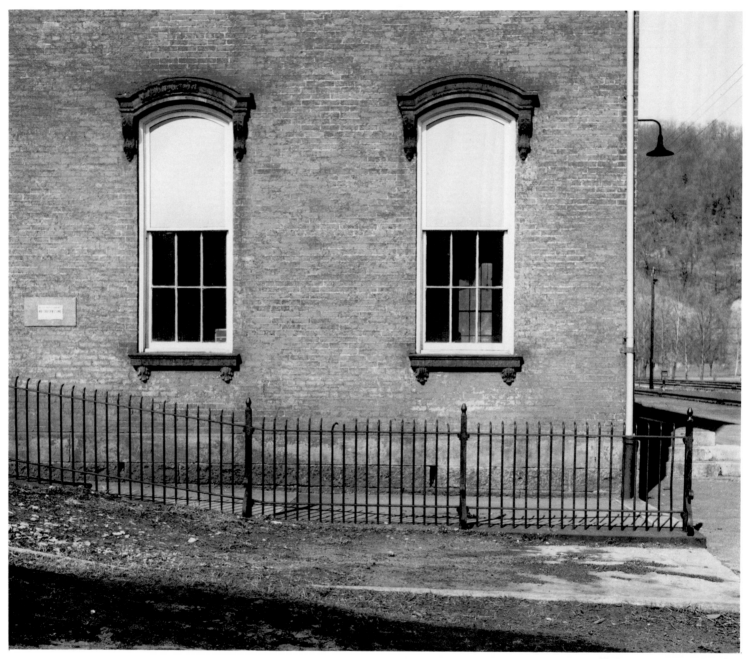

Piedmont, West Virginia: 1964

Mount Vernon, Kentucky: 1974

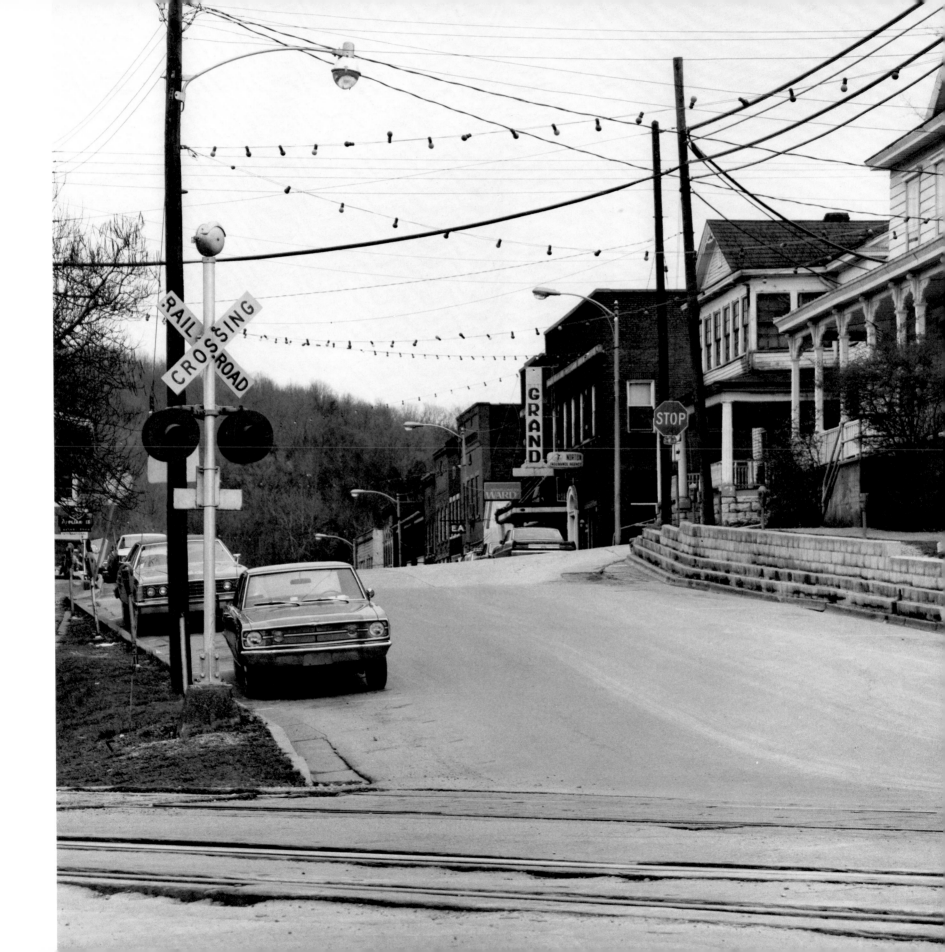

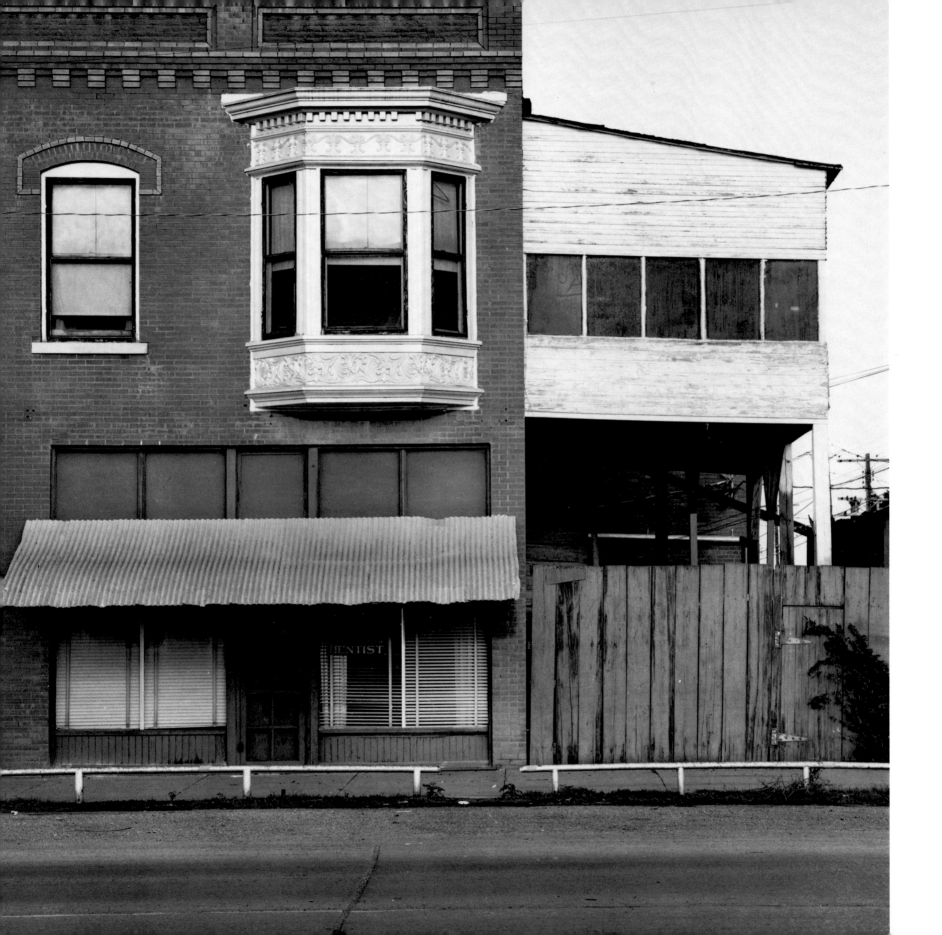

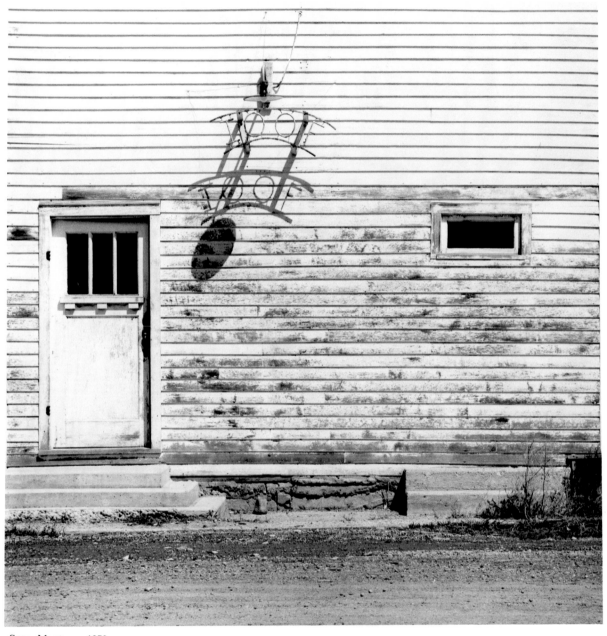

Saco, Montana: 1973

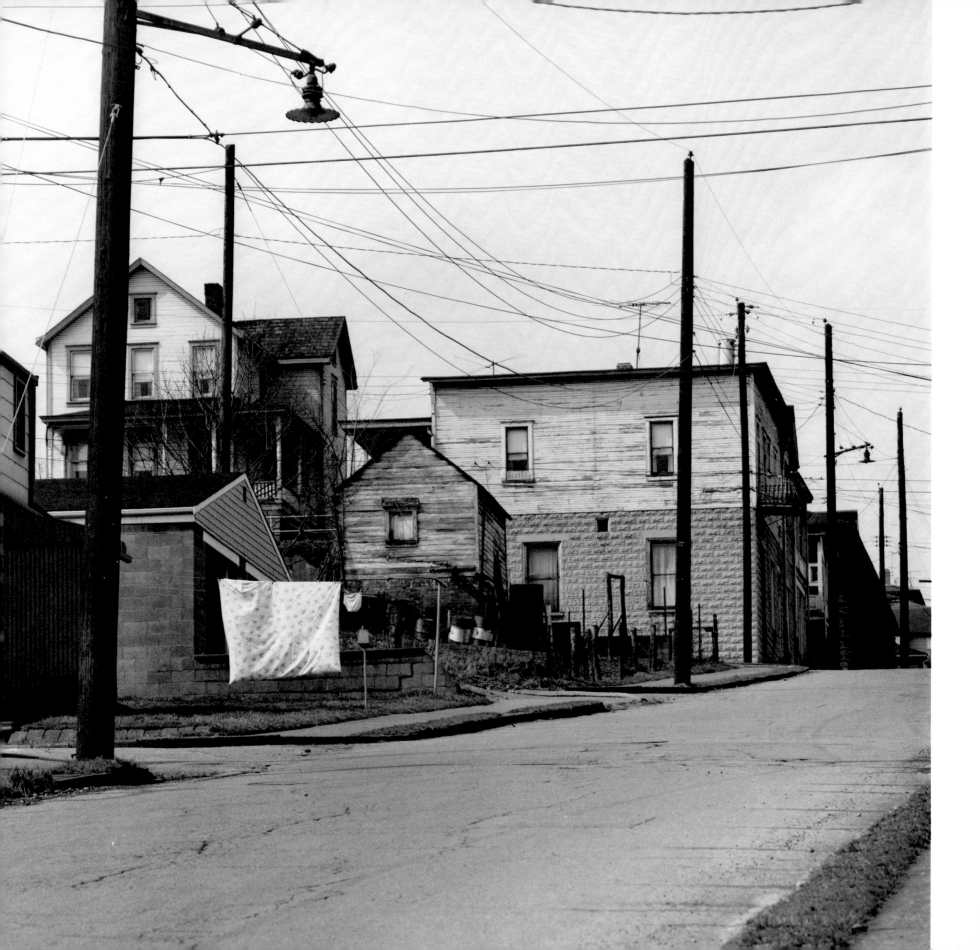

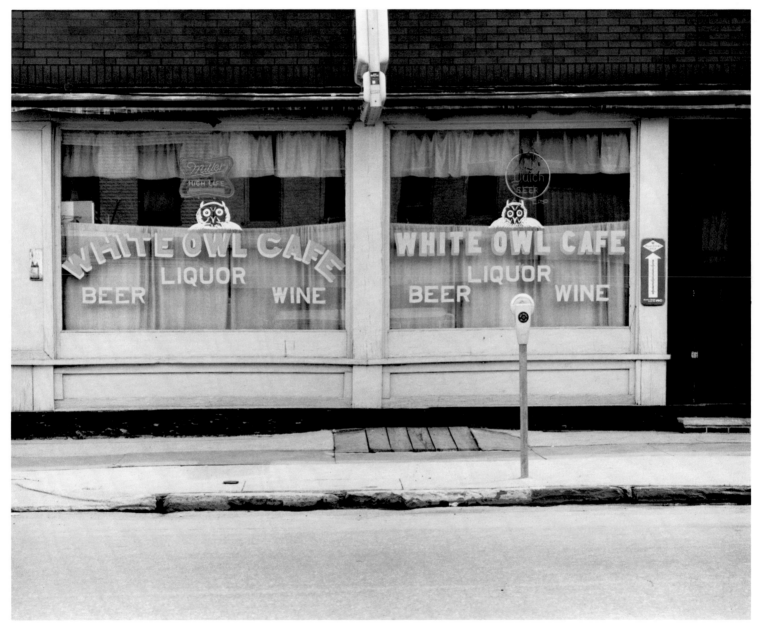

Bucyrus, Ohio: 1973

Donora, Pennsylvania: 1974

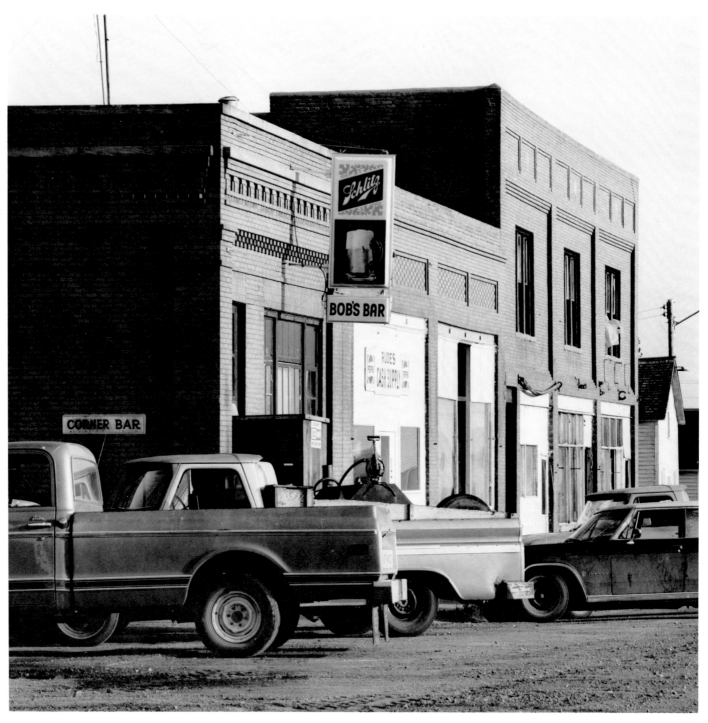

York, North Dakota: 1973

Butte, Montana: 1973

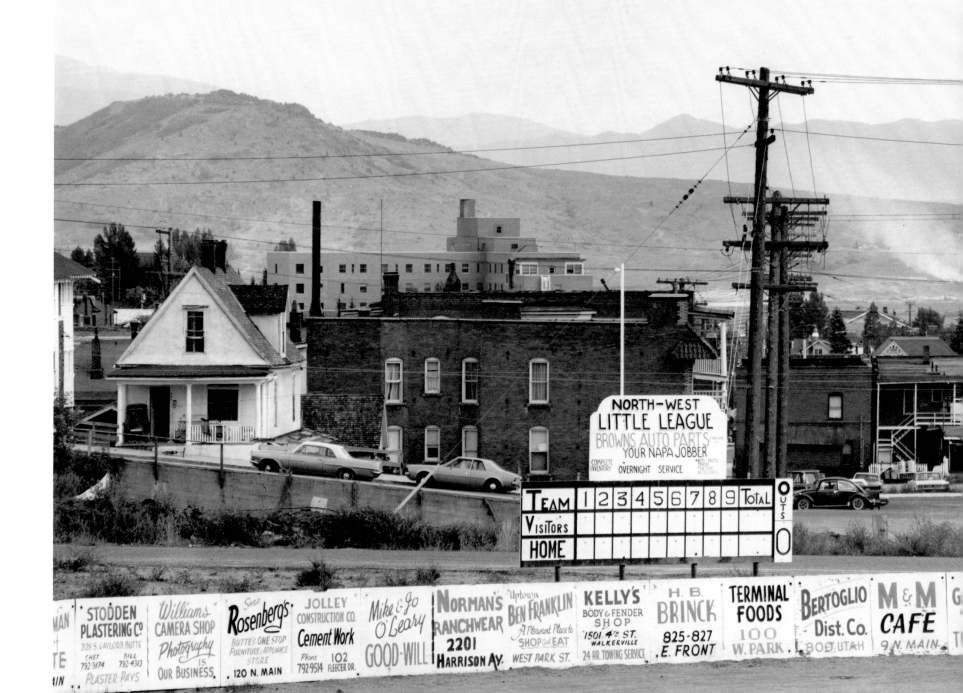

NORTH–WEST
LITTLE LEAGUE
BROWNS AUTO PARTS
YOUR NAPA JOBBER
COMPLETE
INVENTORY OVERNIGHT SERVICE

TEAM	1	2	3	4	5	6	7	8	9	Total
VISITORS										
HOME										

OUTS
0

STODDEN
PLASTERING Cº
2128 S. GAYLORD, BUTTE
CHET BILL
792-9174 792-4313
PLASTER PAYS

Williams
CAMERA SHOP
Photography
IS
OUR BUSINESS.
120 N. MAIN

Shop
Rosenberg's
BUTTE'S ONE STOP
FURNITURE & APPLIANCE
STORE

JOLLEY
CONSTRUCTION CO.
Cement Work
Phone 102
792-9514 FLEECER DR.

Mike & Jo
O'Leary
GOOD-WILL

Norman's
RANCHWEAR
2201
HARRISON AV.

Uptown
BEN FRANKLIN
A Pleasant Place to
SHOP and EAT
WEST PARK ST.

KELLY'S
BODY & FENDER
SHOP
1501 4TH ST.
WALKERVILLE
24-HR. TOWING SERVICE

H. B.
BRINCK
825-827
E. FRONT

TERMINAL
FOODS
100
W. PARK

BERTOGLIO
Dist. Co.
BOB, UTAH

M & M
CAFE
9 N. MAIN

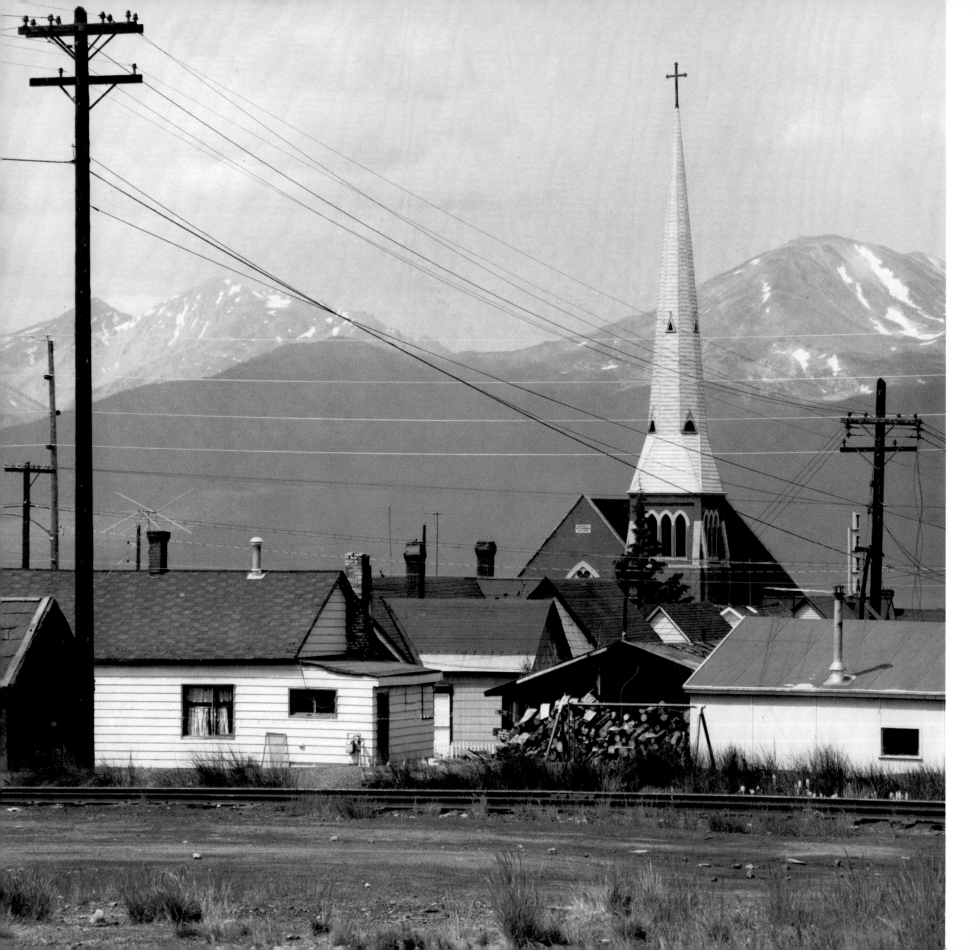

Leadville,
Colorado:
1973

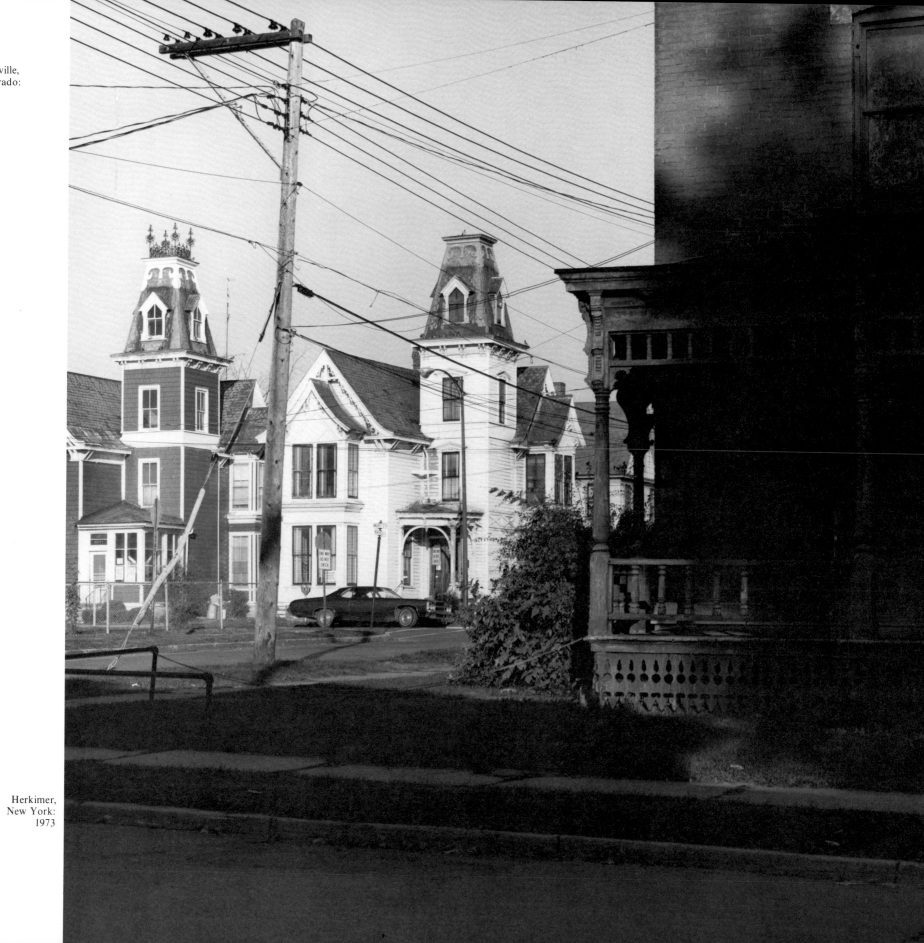

Herkimer,
New York:
1973

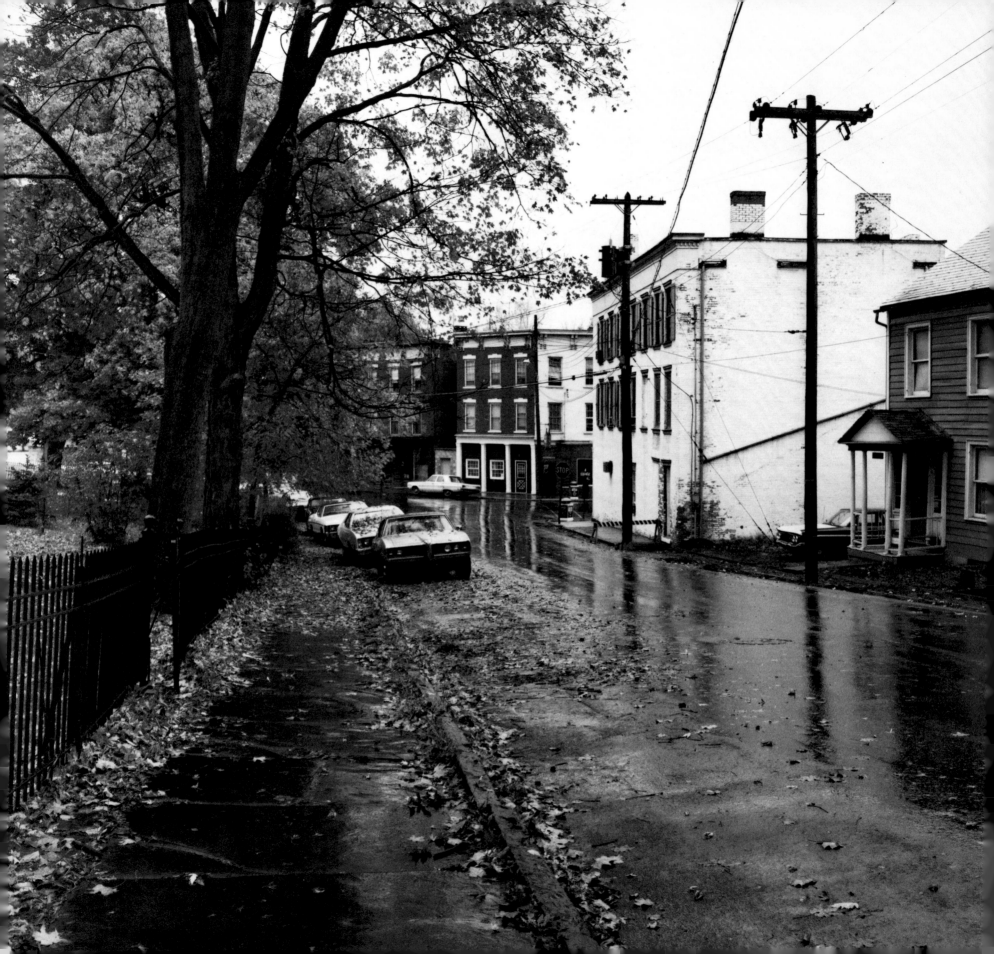

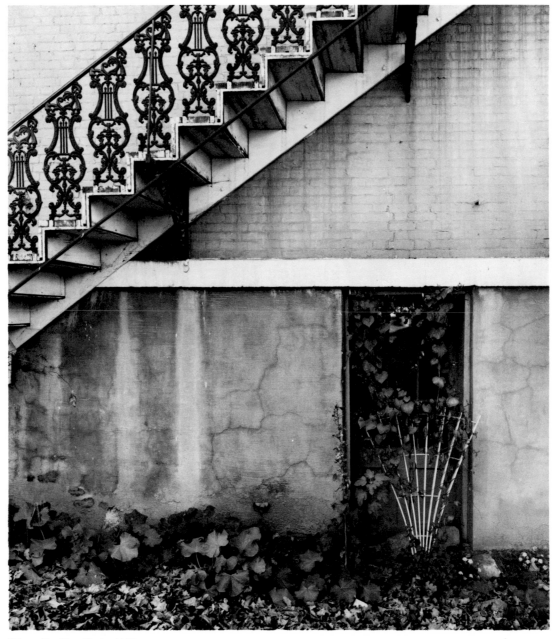

Waterville, New York: 1973

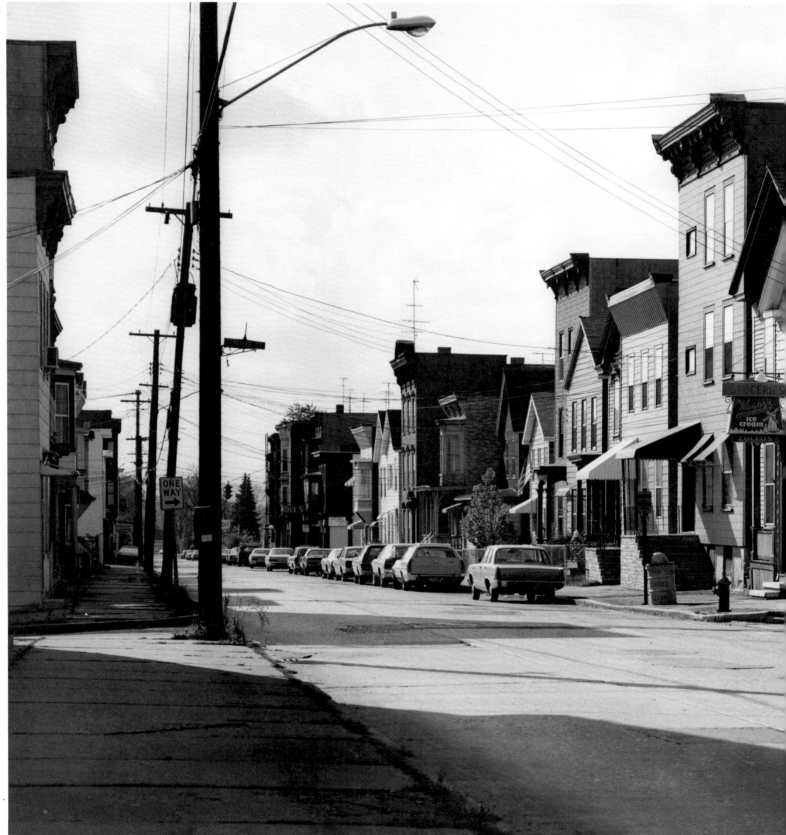

76

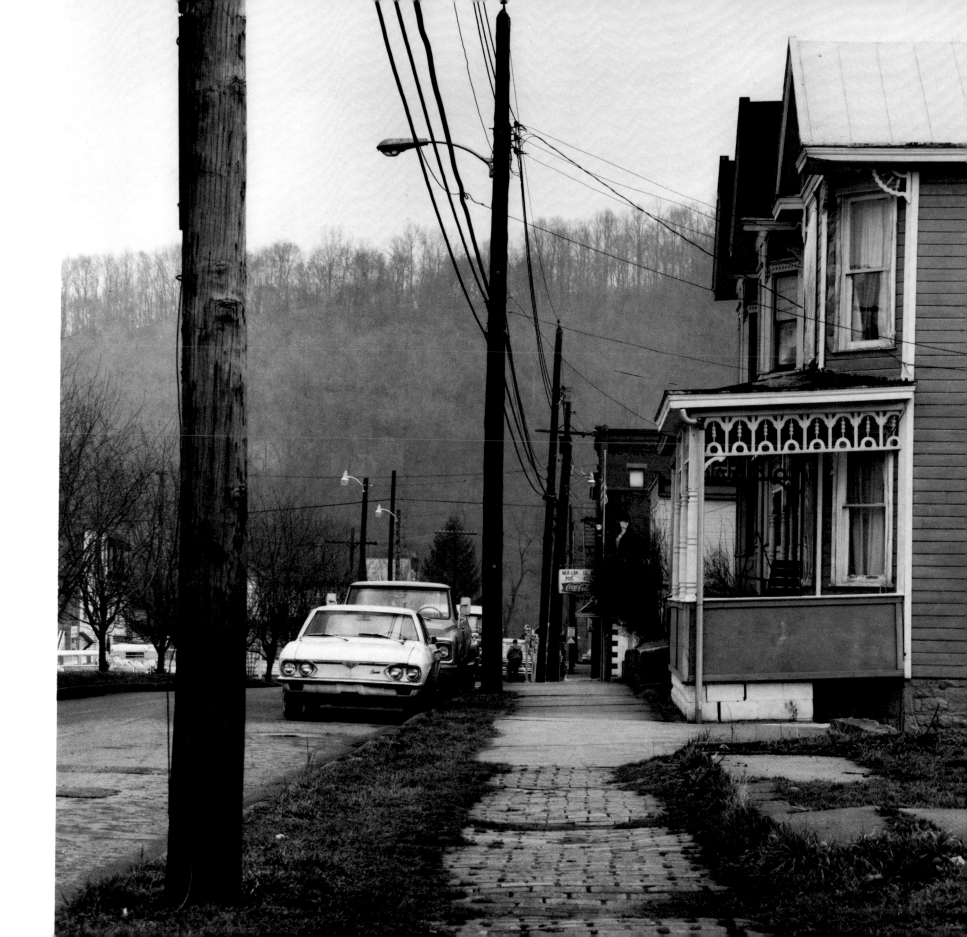

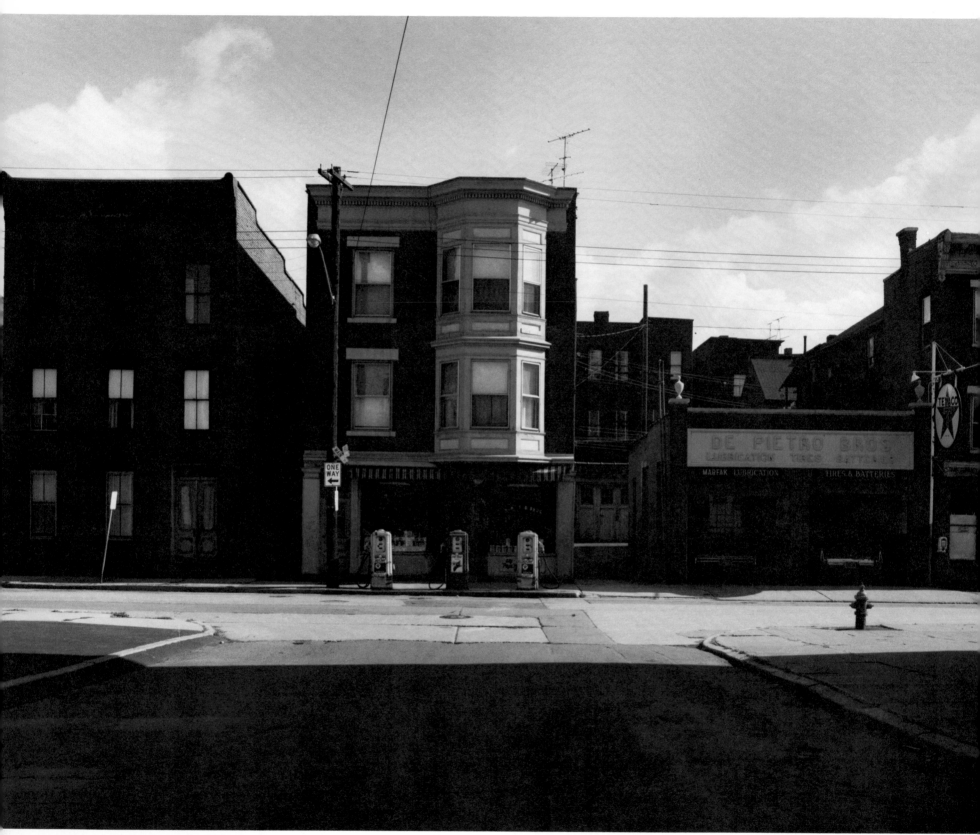

Cohoes, New York: 1973

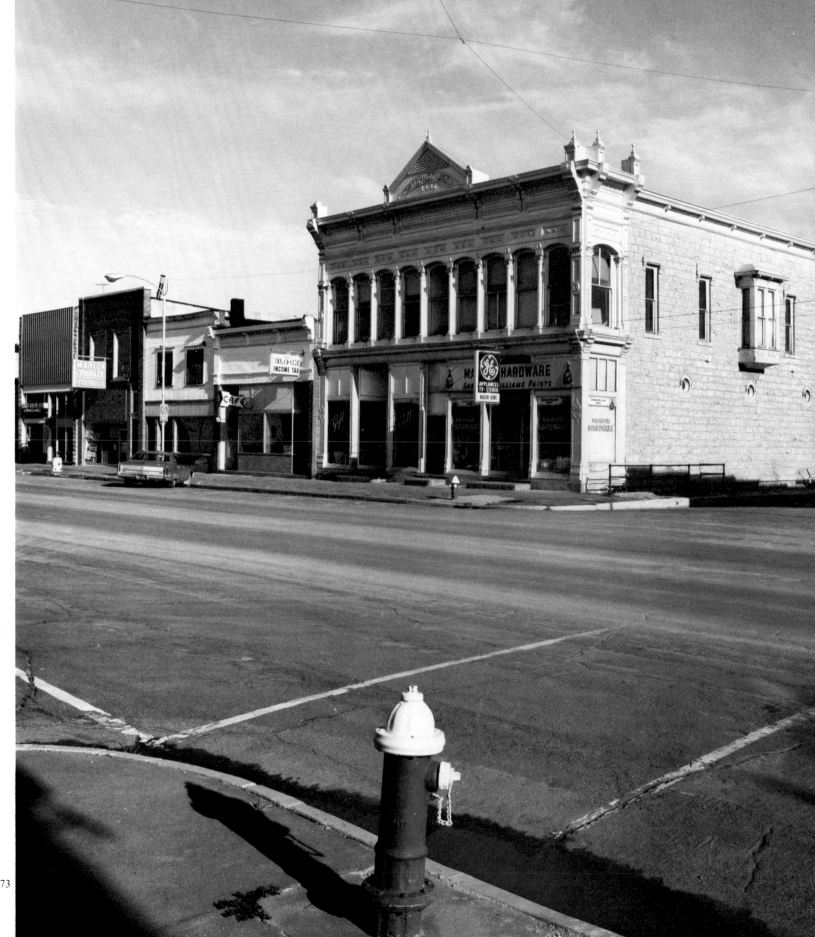

Marion, Kansas: 1973

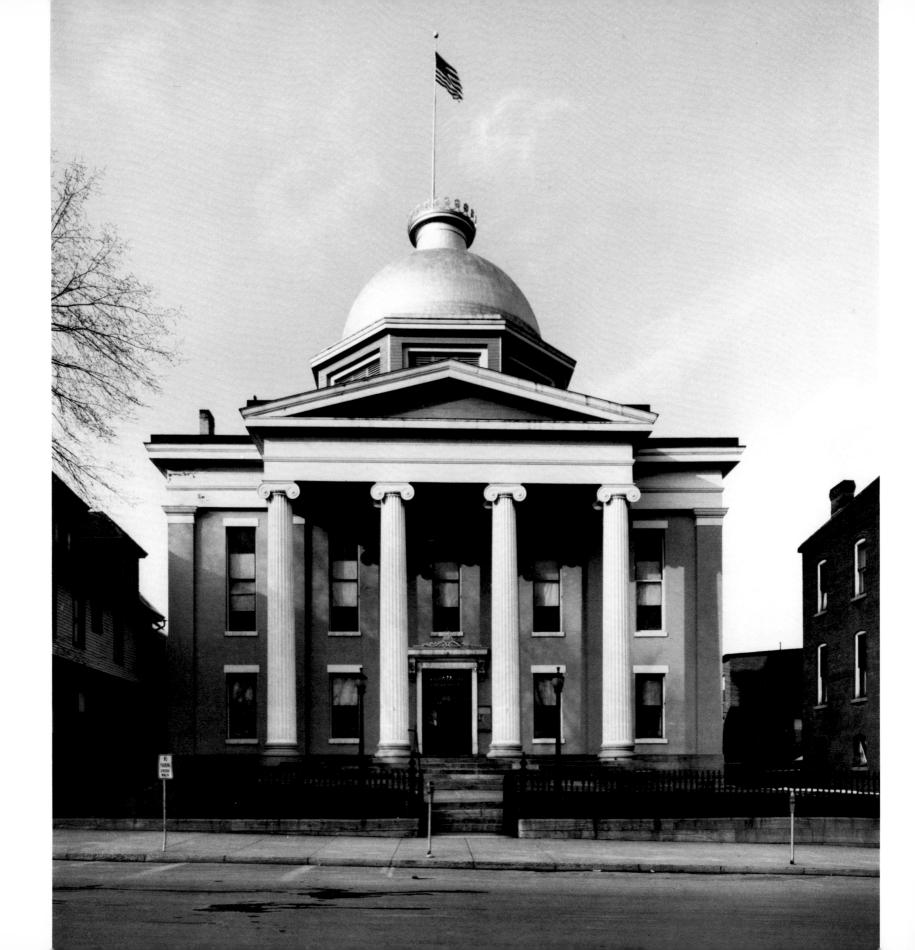

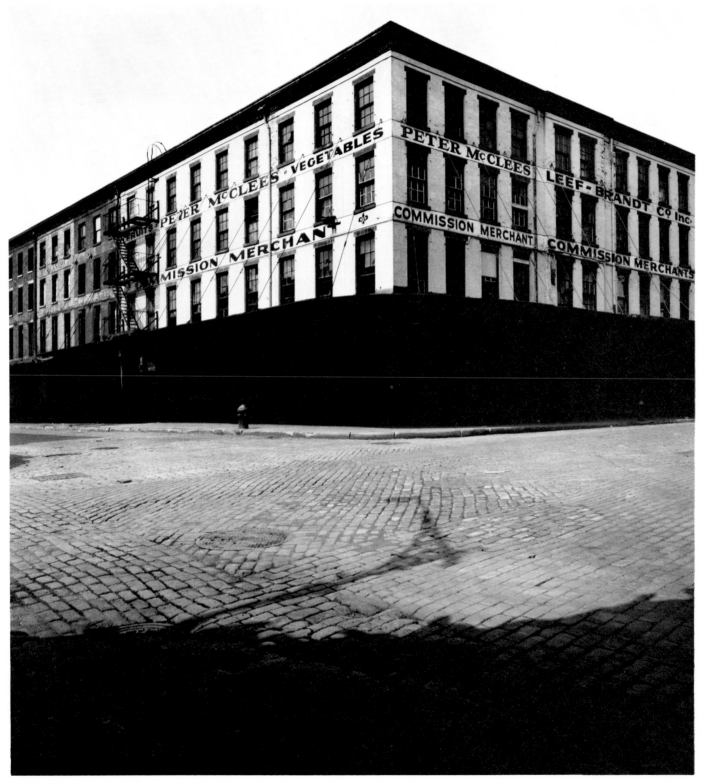

New York, New York: 1967

Lyons, New York: 1966

Binghamton, New York: 1966

Richmond, Virginia: 1967

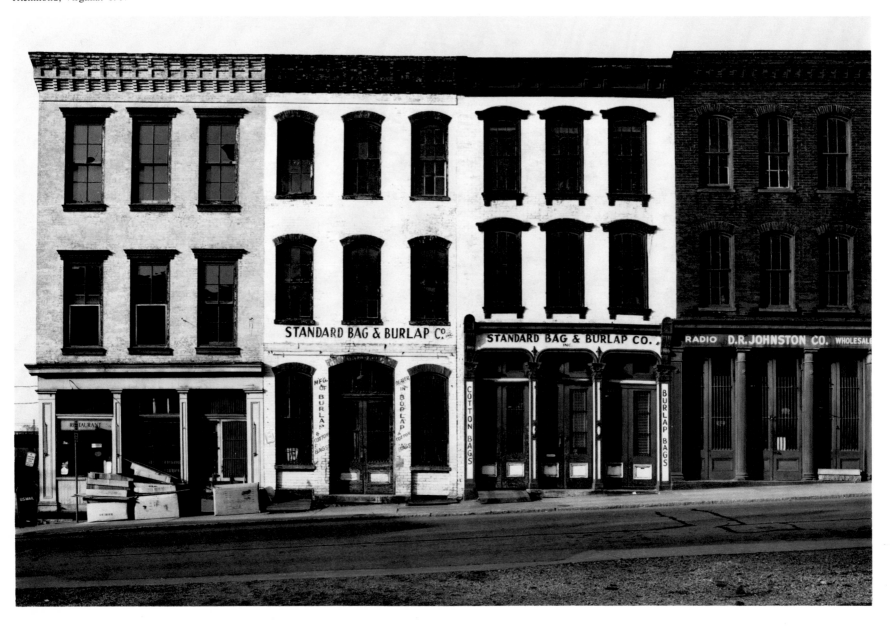

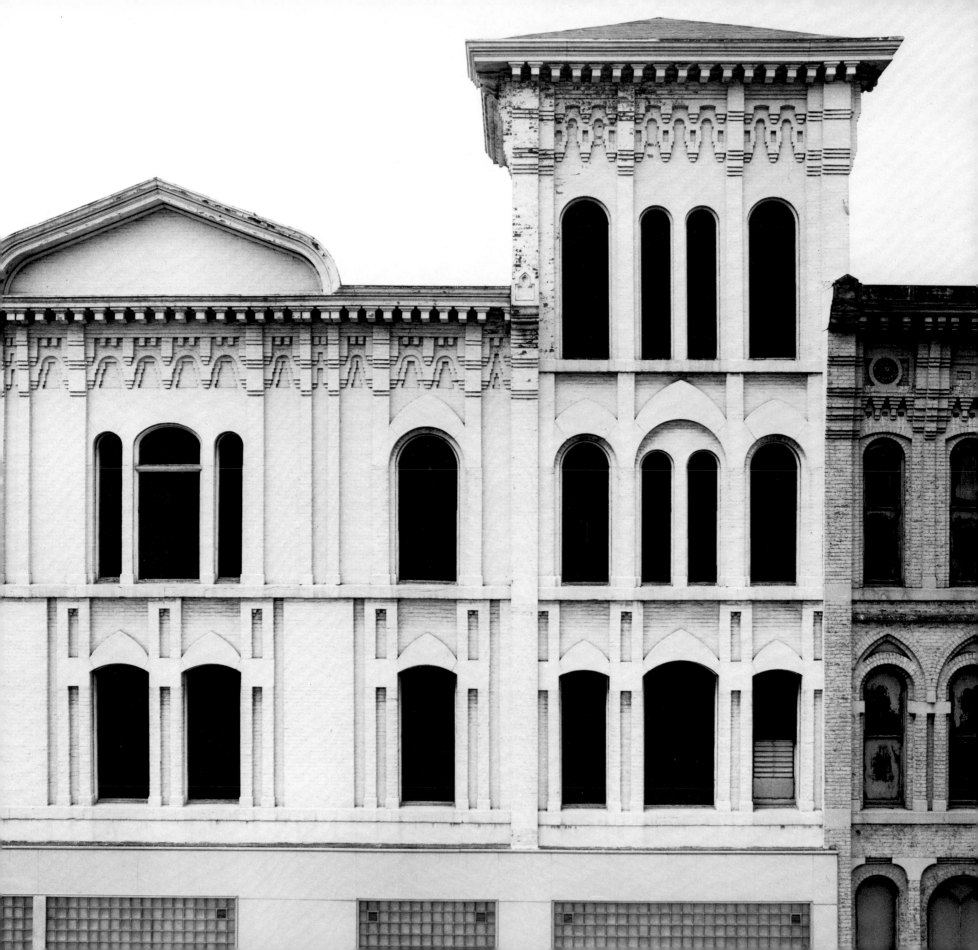

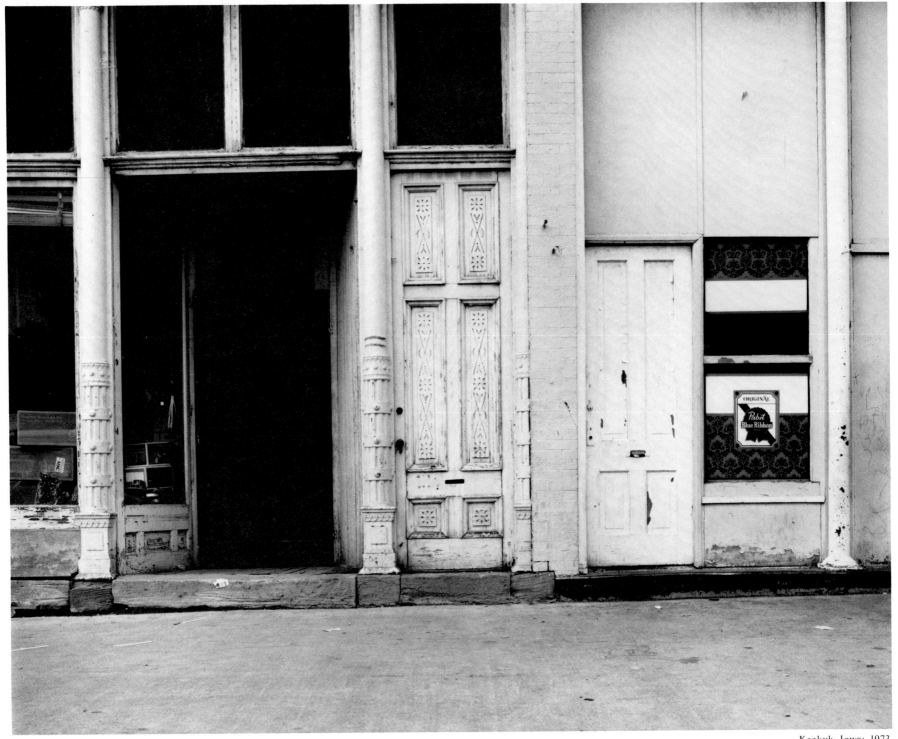

Keokuk, Iowa: 1973

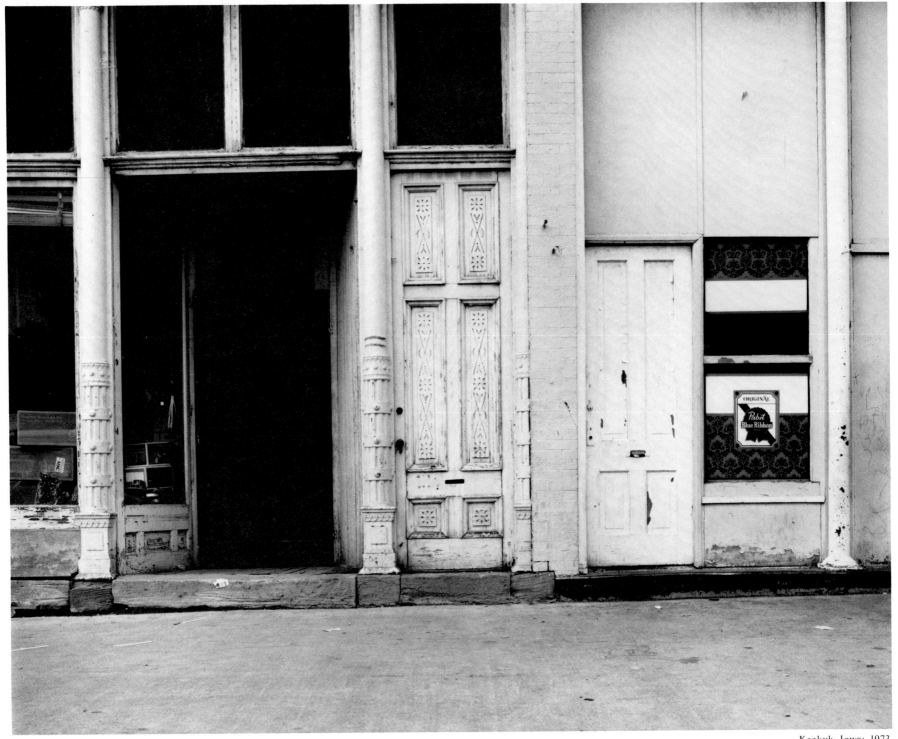

Keokuk, Iowa: 1973

84

Holyoke, Massachusetts: 1973

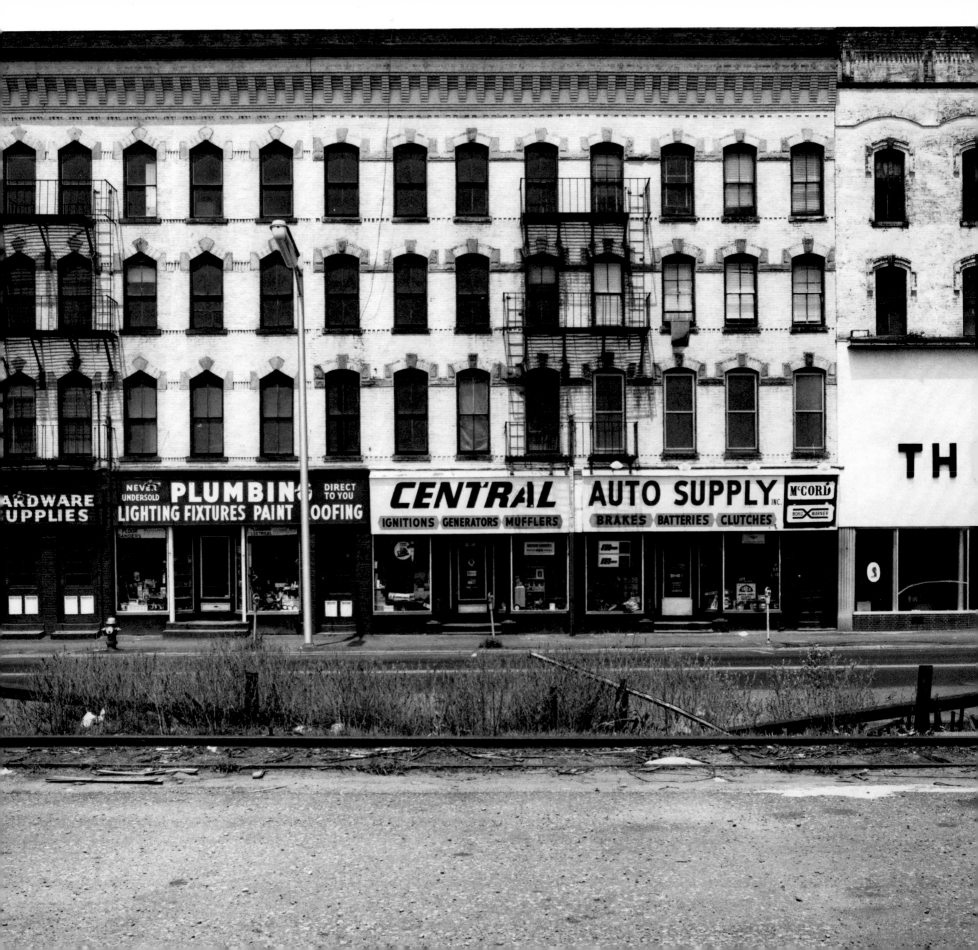

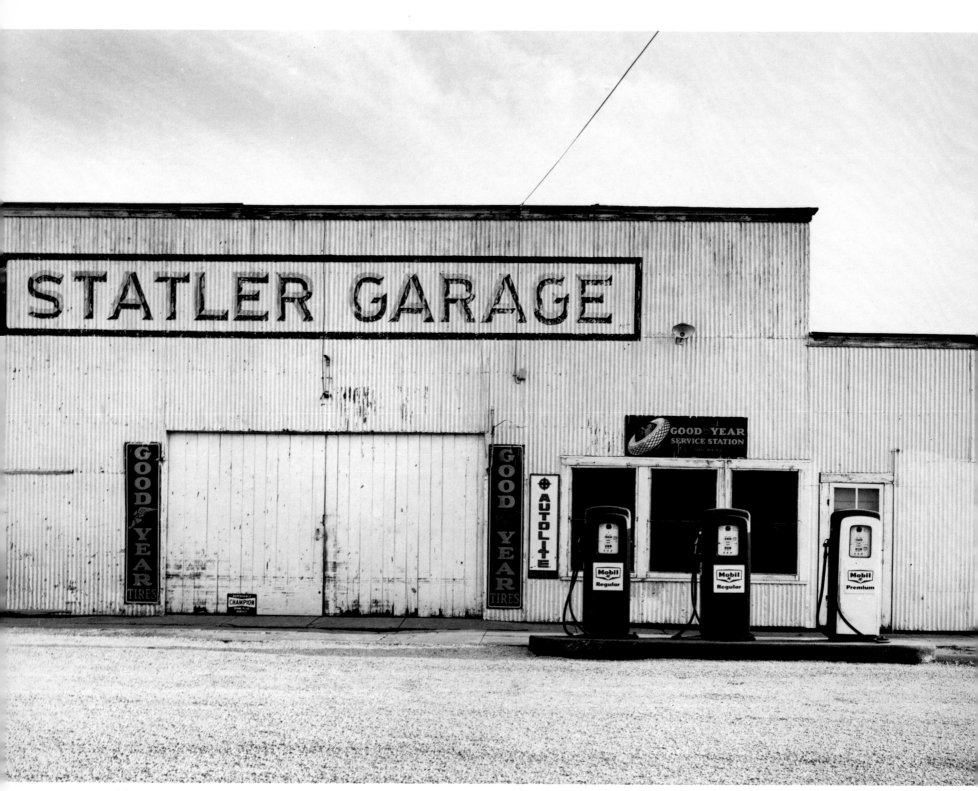

Gotebo, Oklahoma: 1969

St. Johnsville, New York: 1973

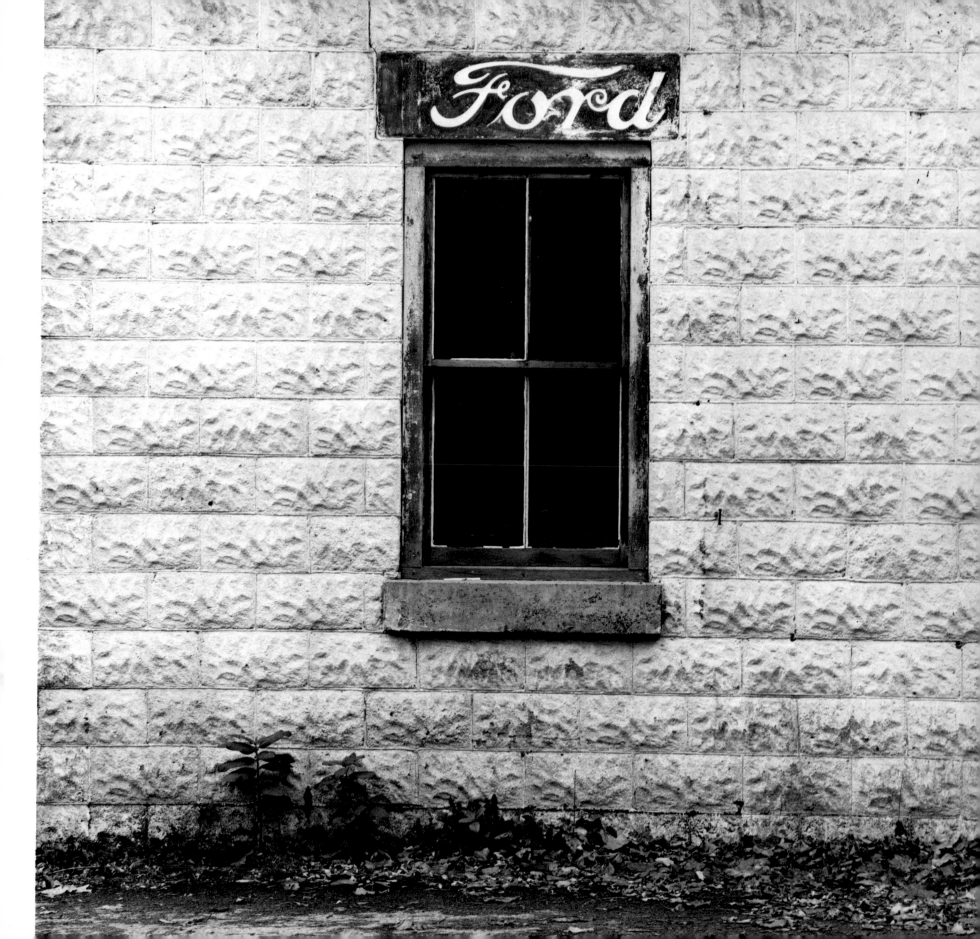

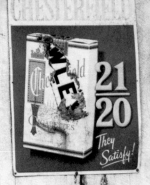

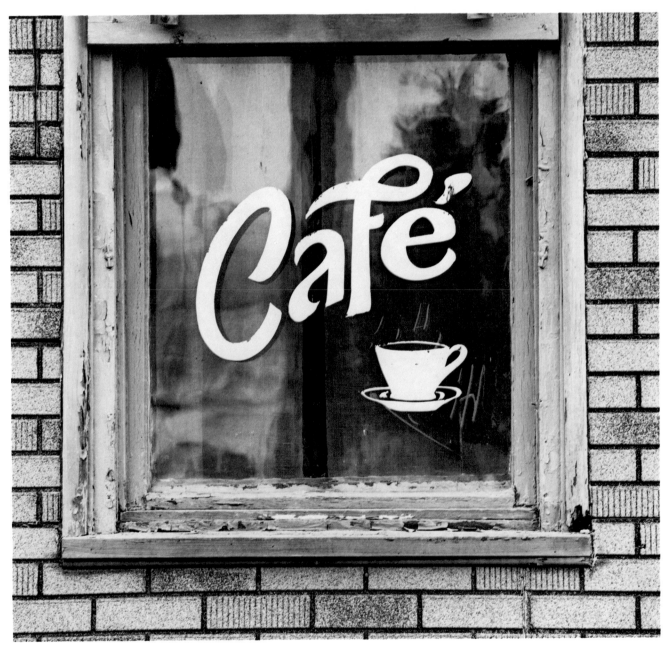

Lanark, Illinois: 1969

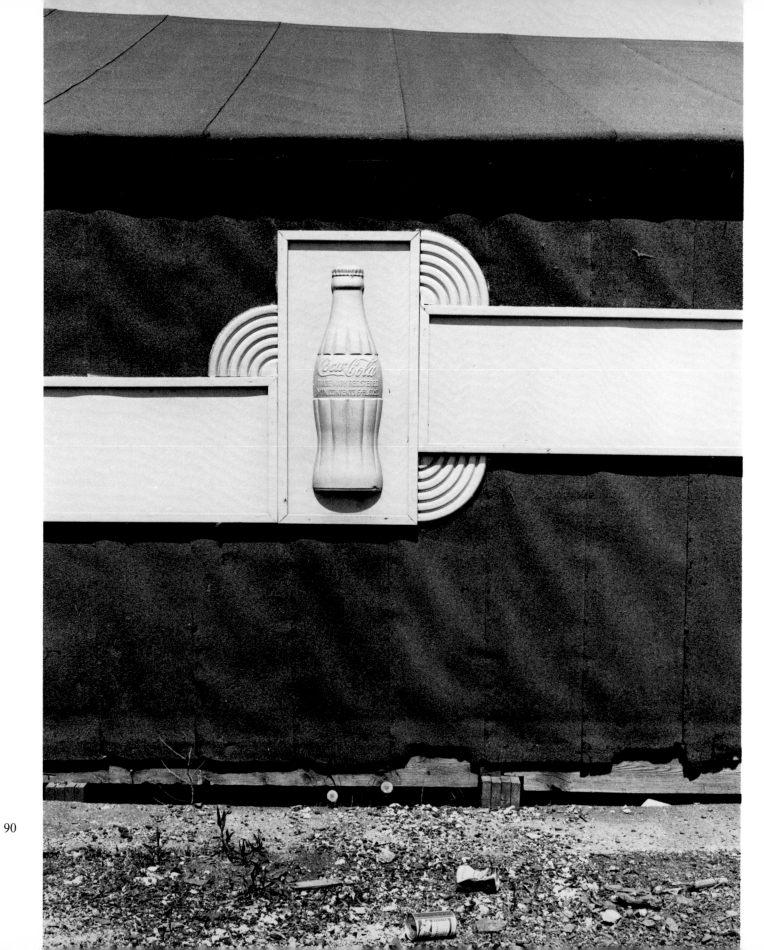

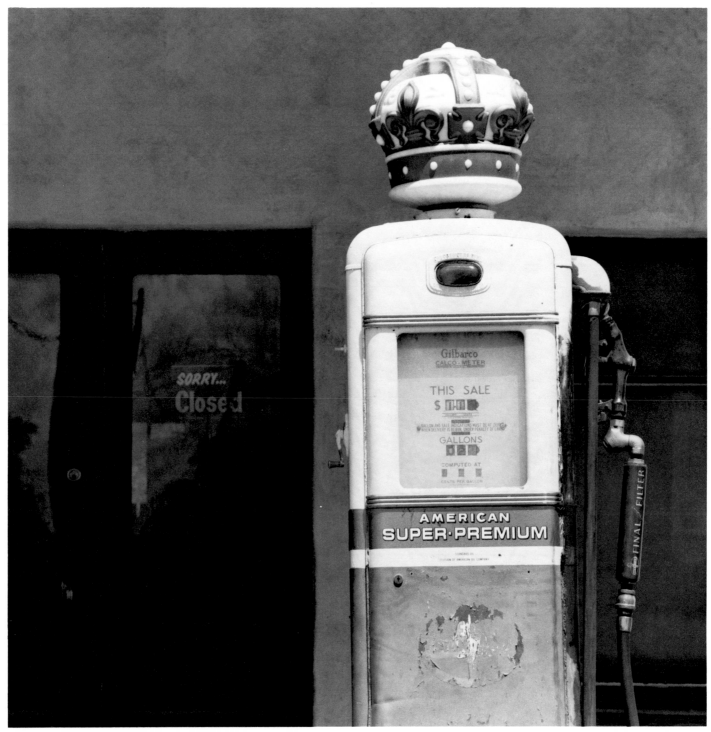

Hazelton, North Dakota: 1971

Sodus Point, New York: 1966

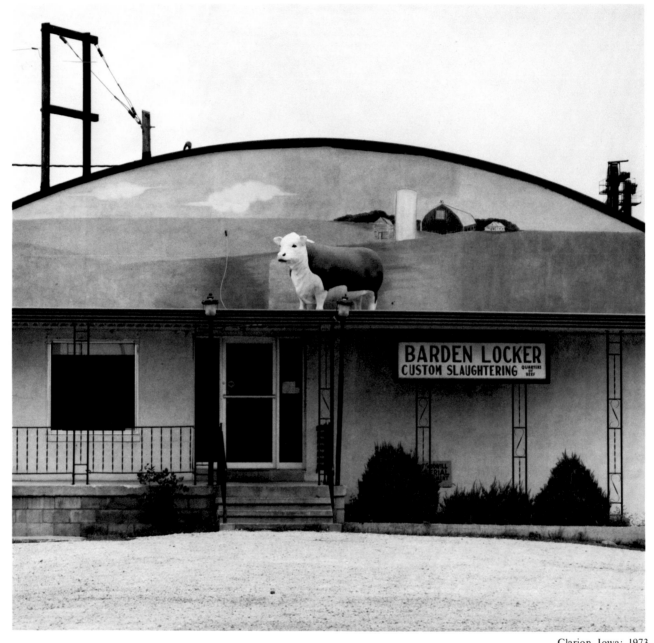

Clarion, Iowa: 1973

(near) Angola, Indiana: 1969

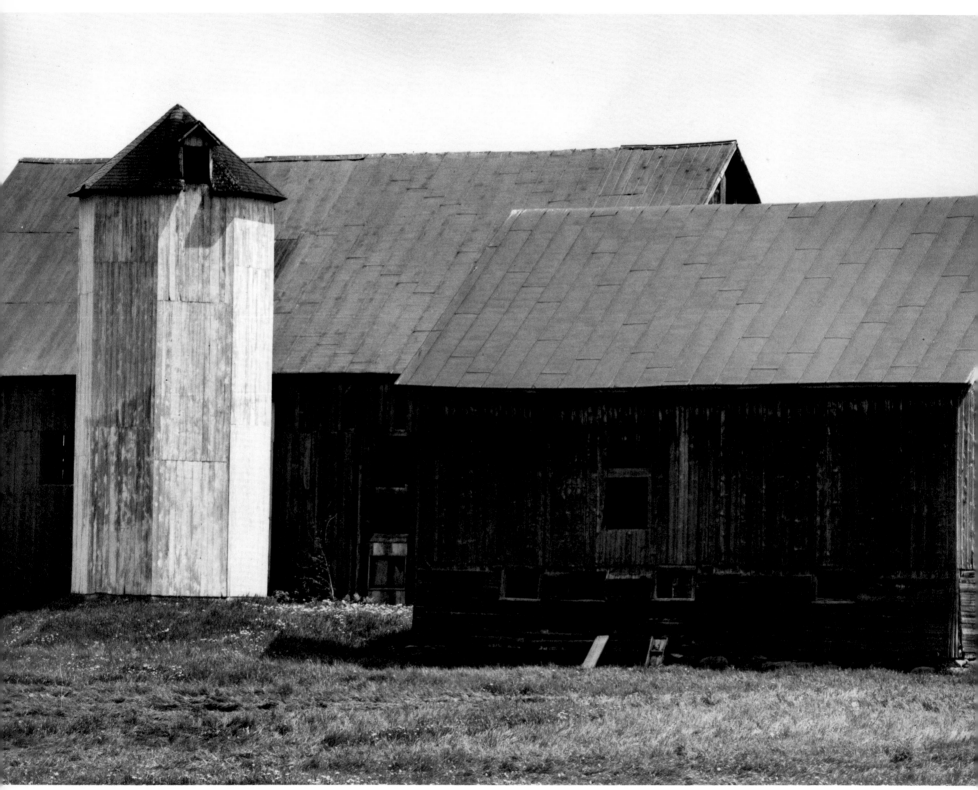

Fairfield, Vermont: 1971

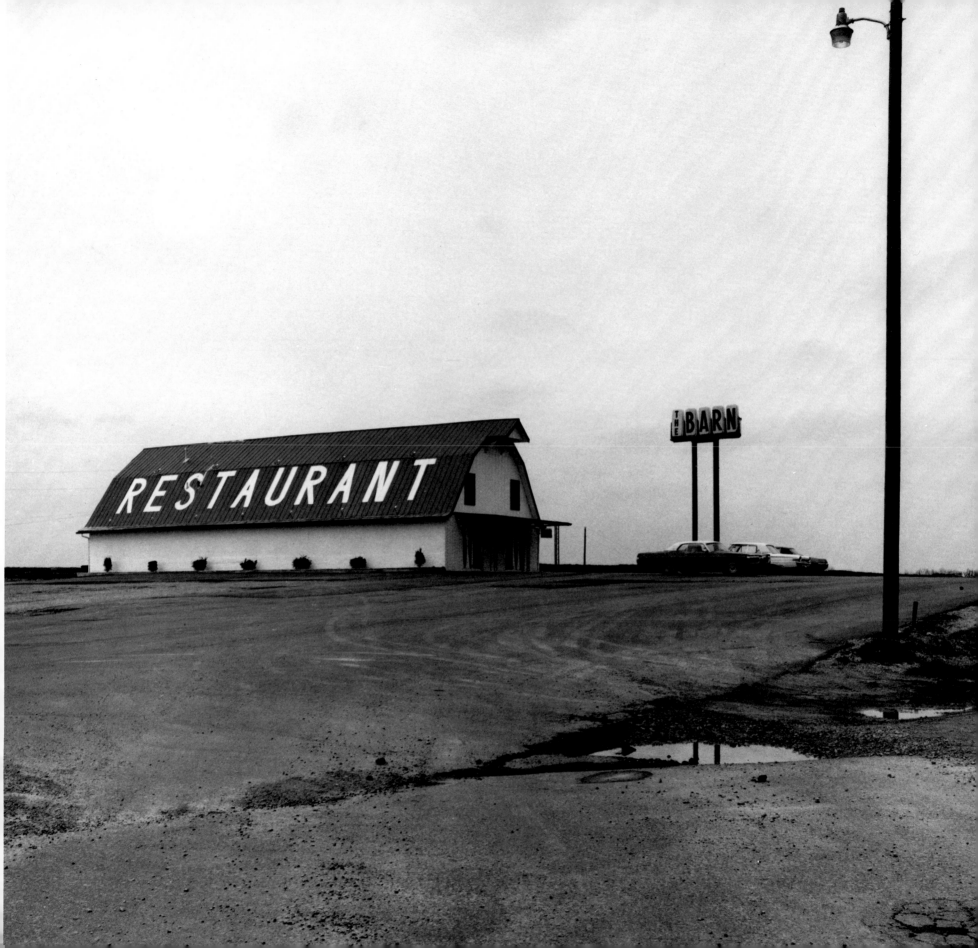

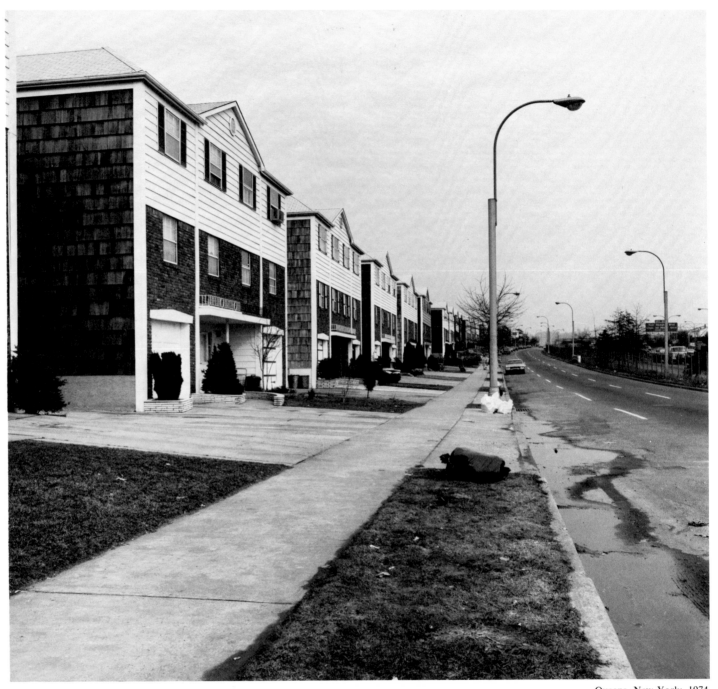

Queens, New York: 1974

Catskill, New York: 1973

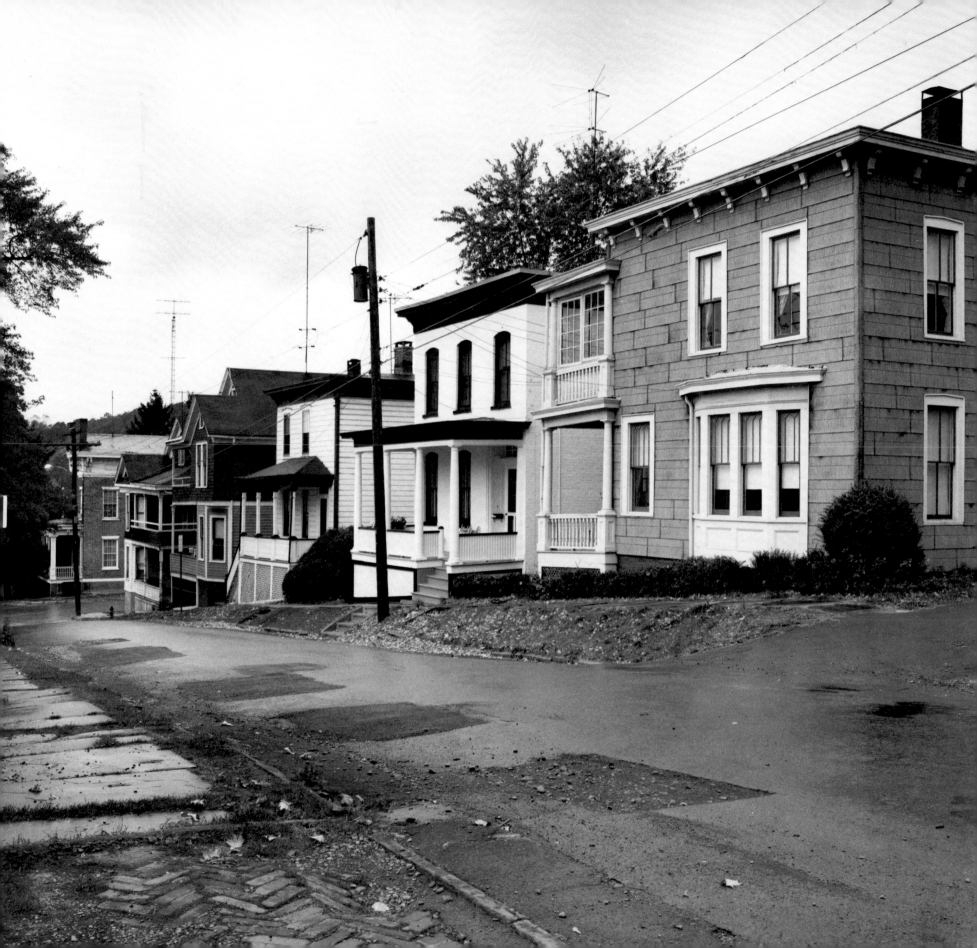

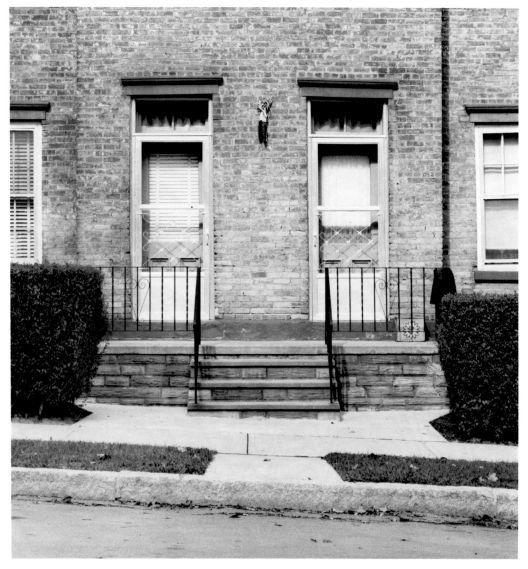

Cohoes, New York: 1973

Galena, Illinois: 1973

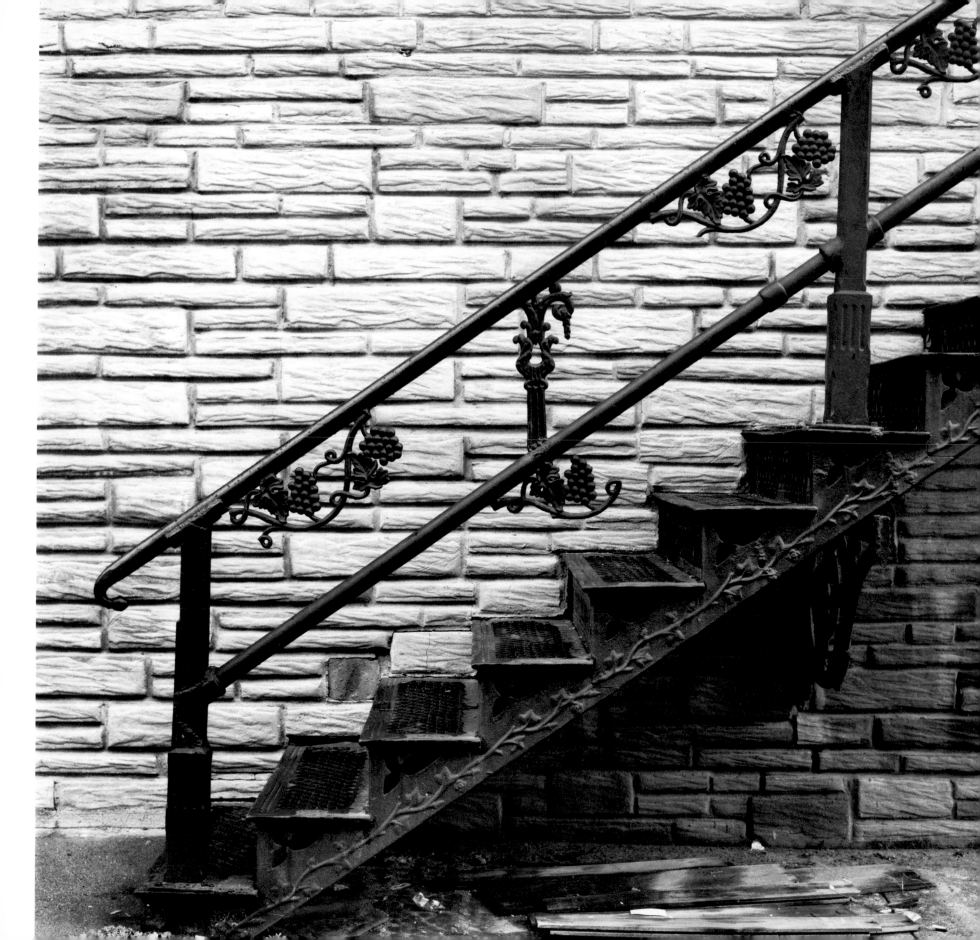

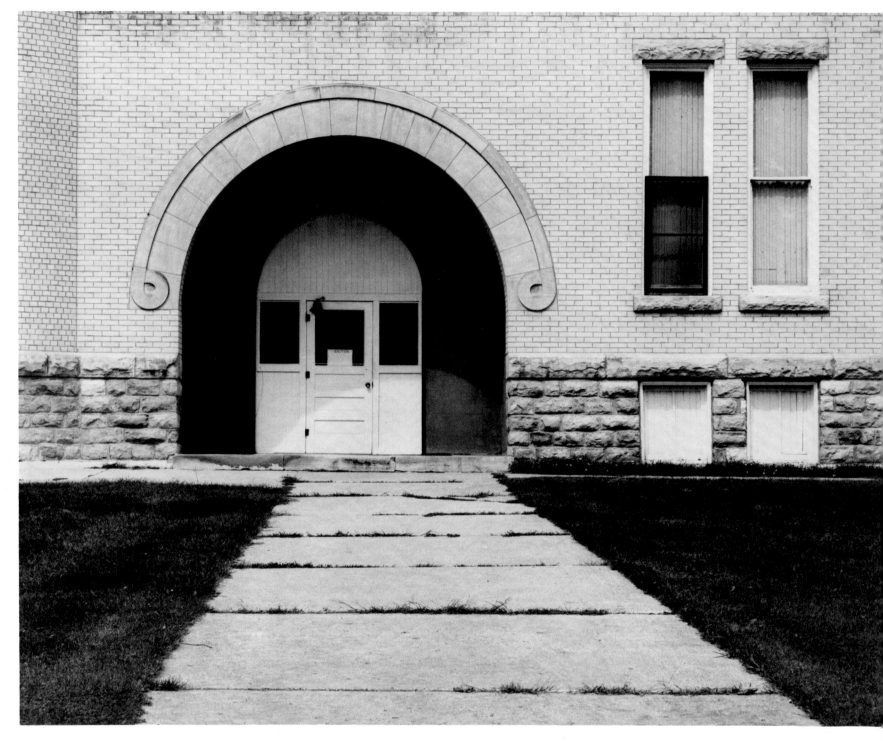

Clarion, Iowa: 1973

Richmond, Kentucky: 1974

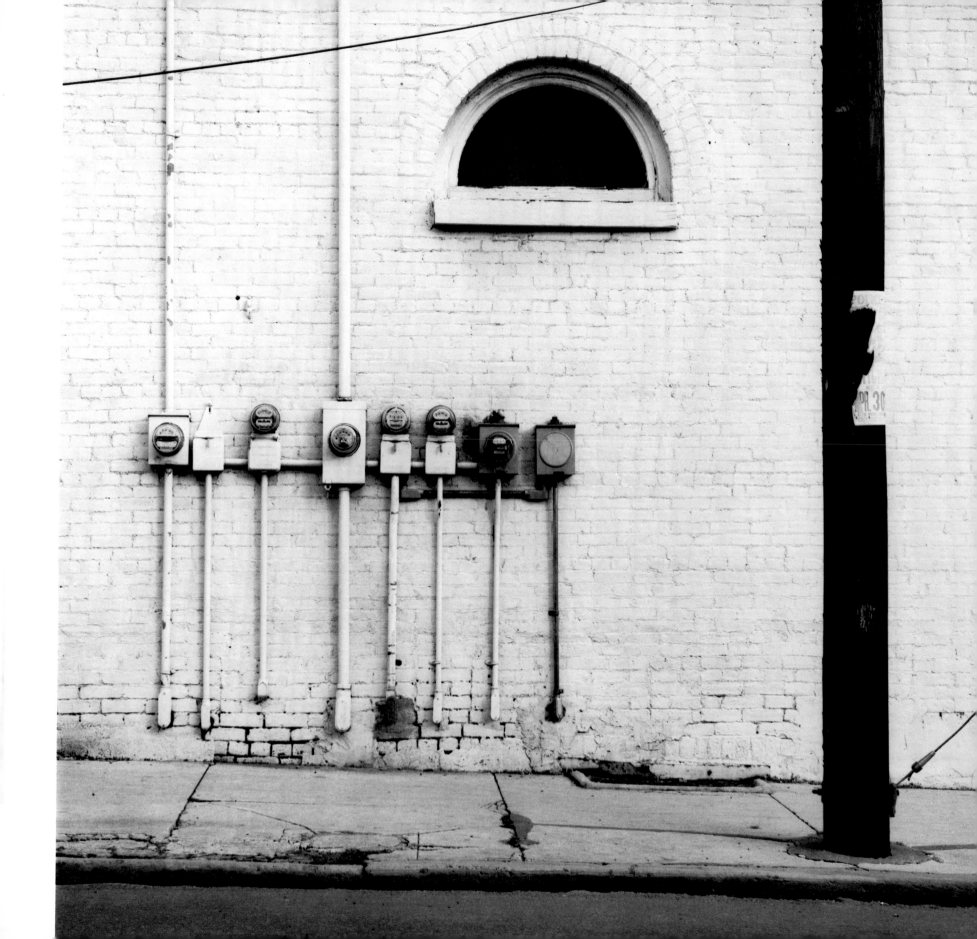

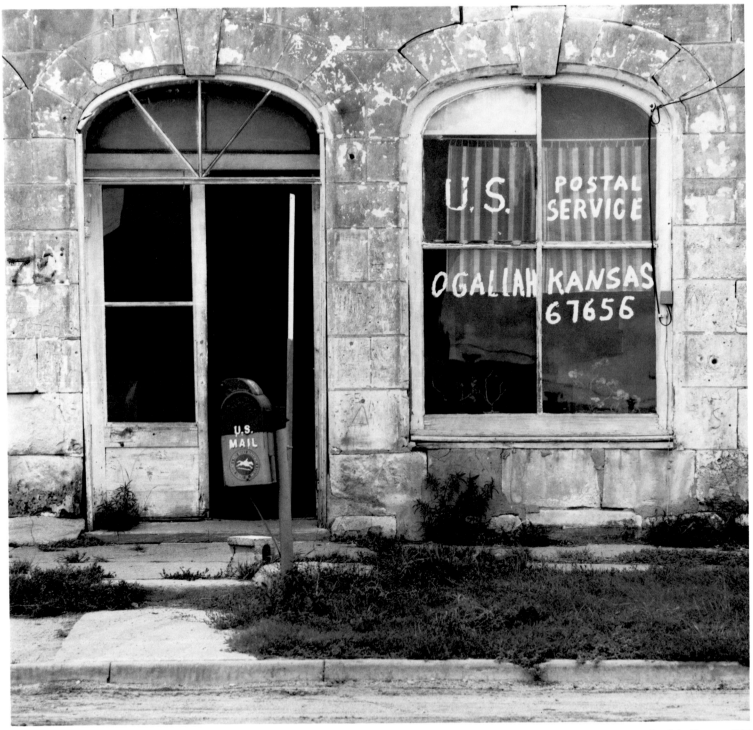

Ogallah, Kansas: 1973

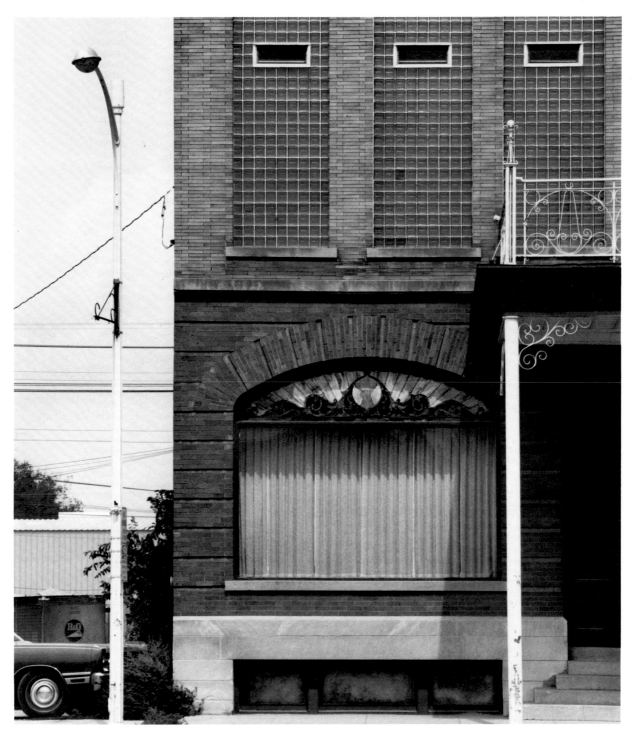

Webster, Iowa: 1973

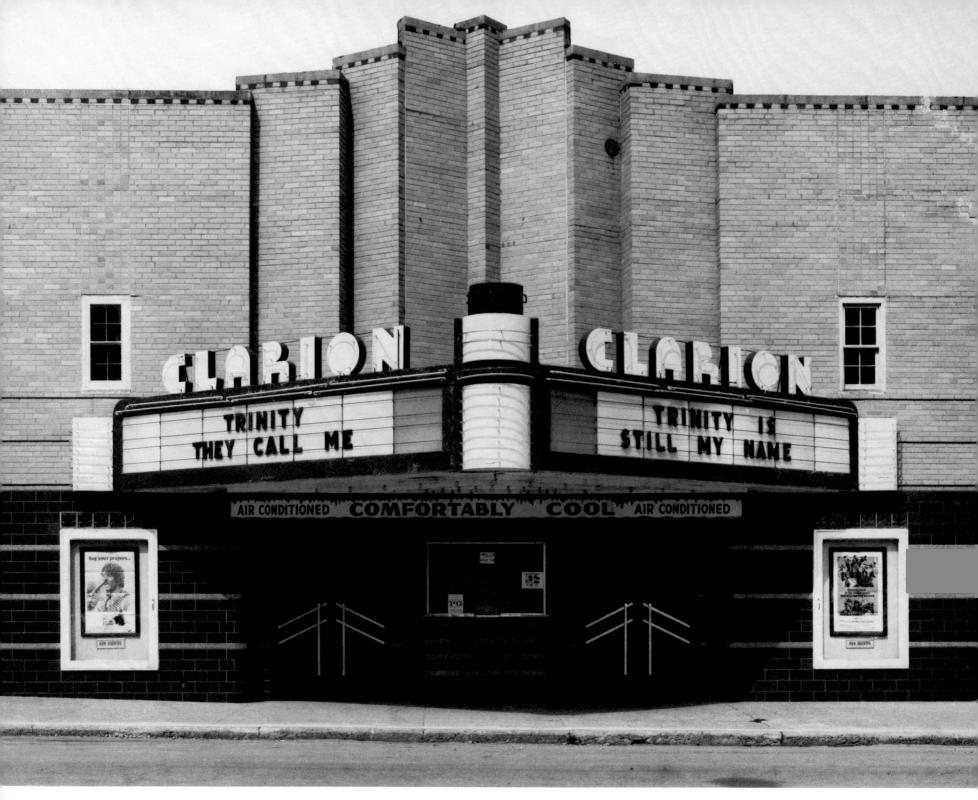

104

Clarion, Iowa: 1973

Manhasset, New York: 1974

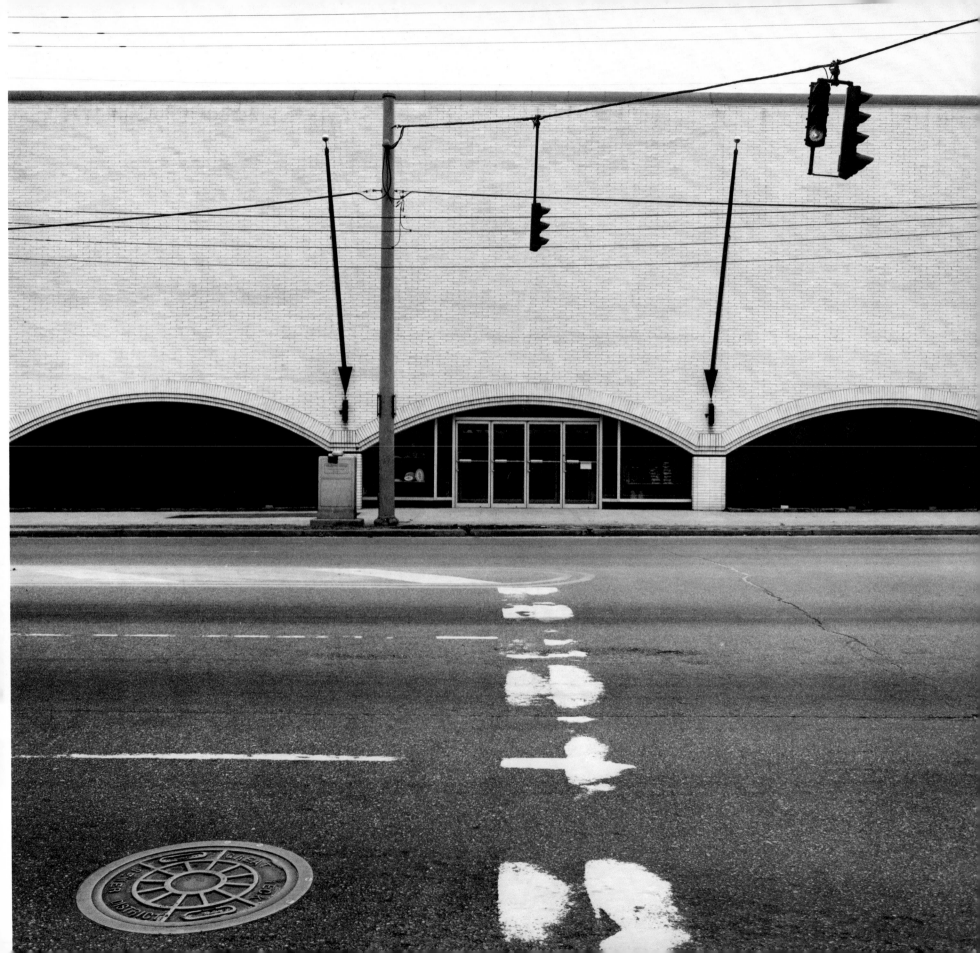

Clarion, Iowa: 1973

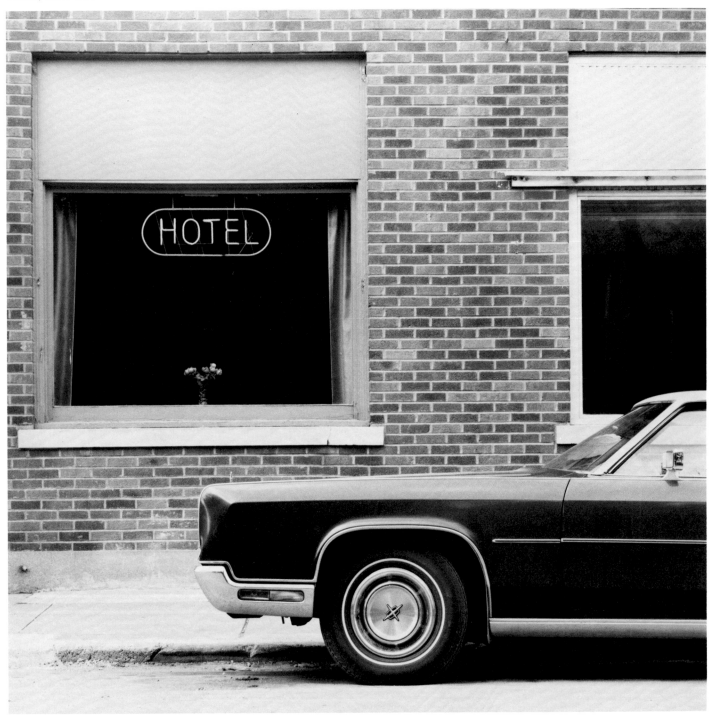

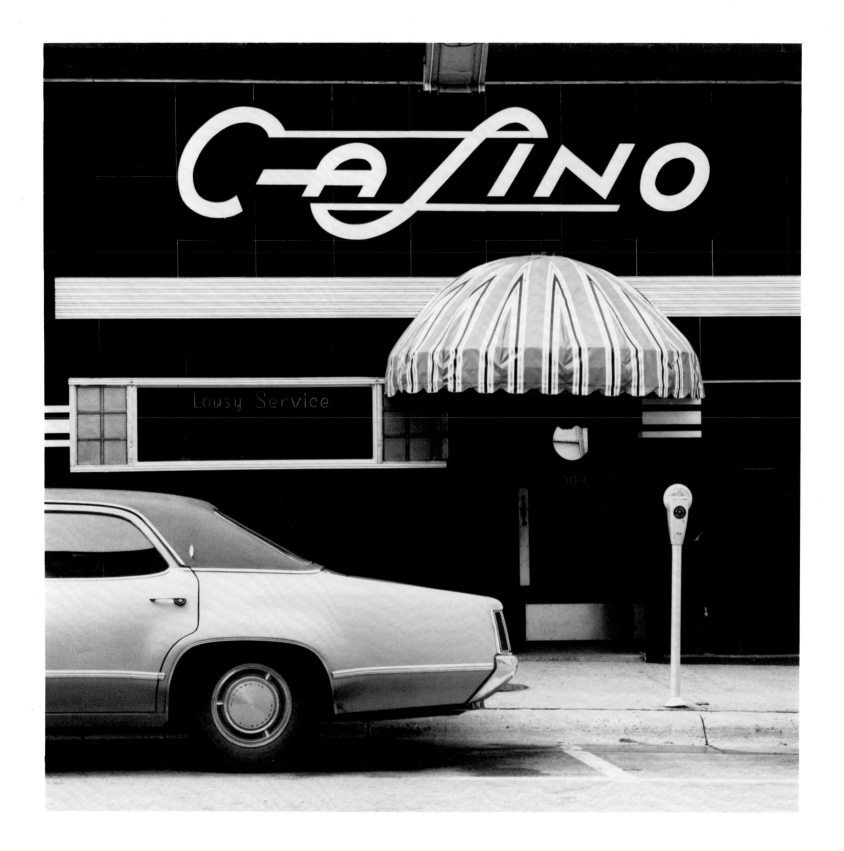

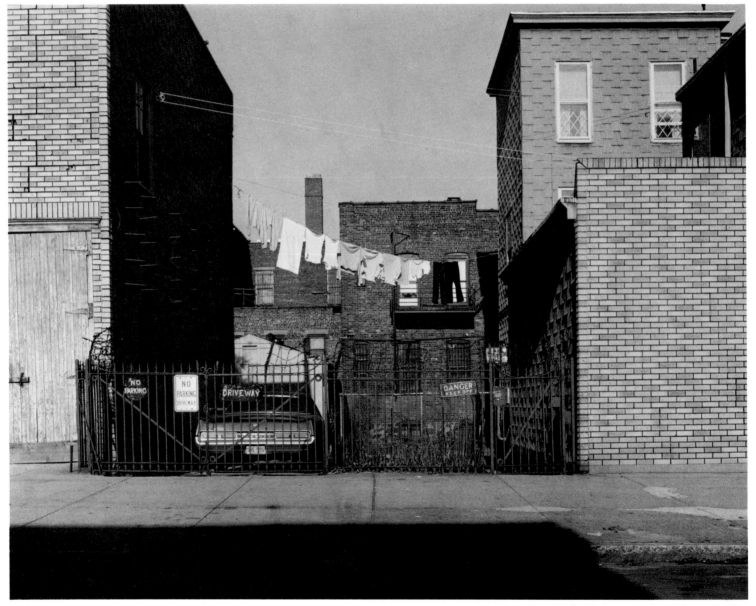

Jersey City, New Jersey: 1974

Secaucus, New Jersey: 1974

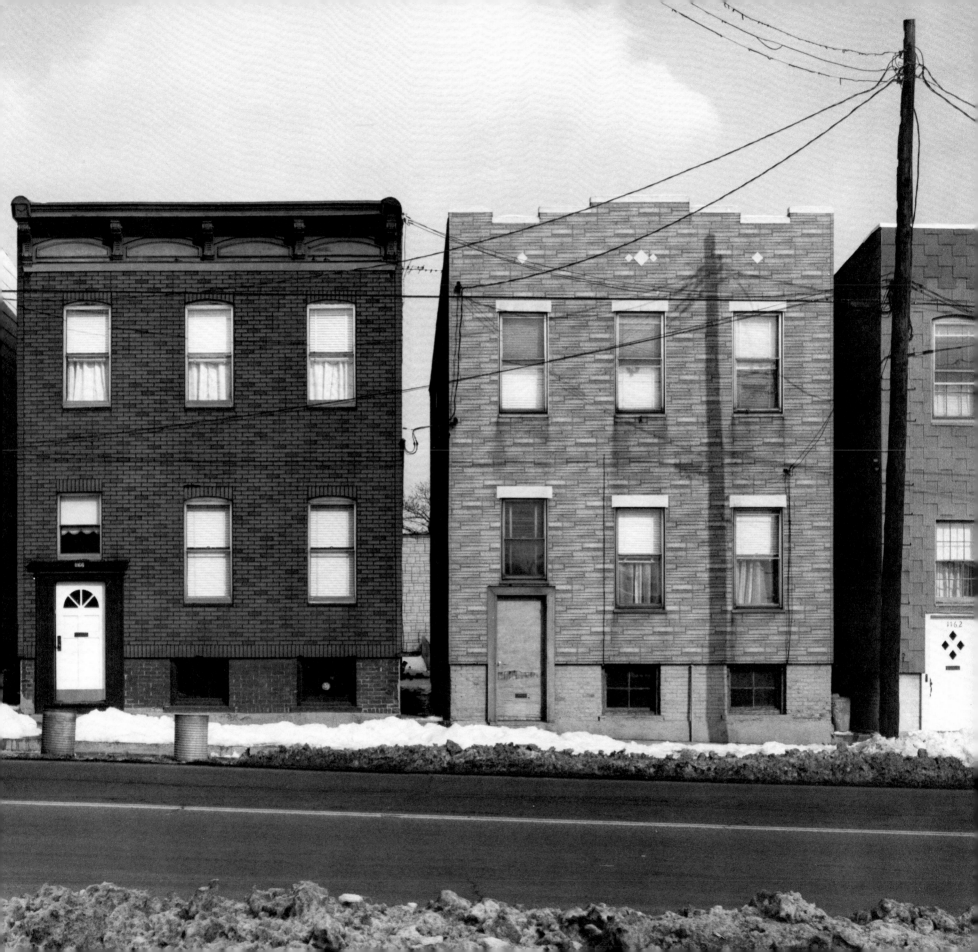

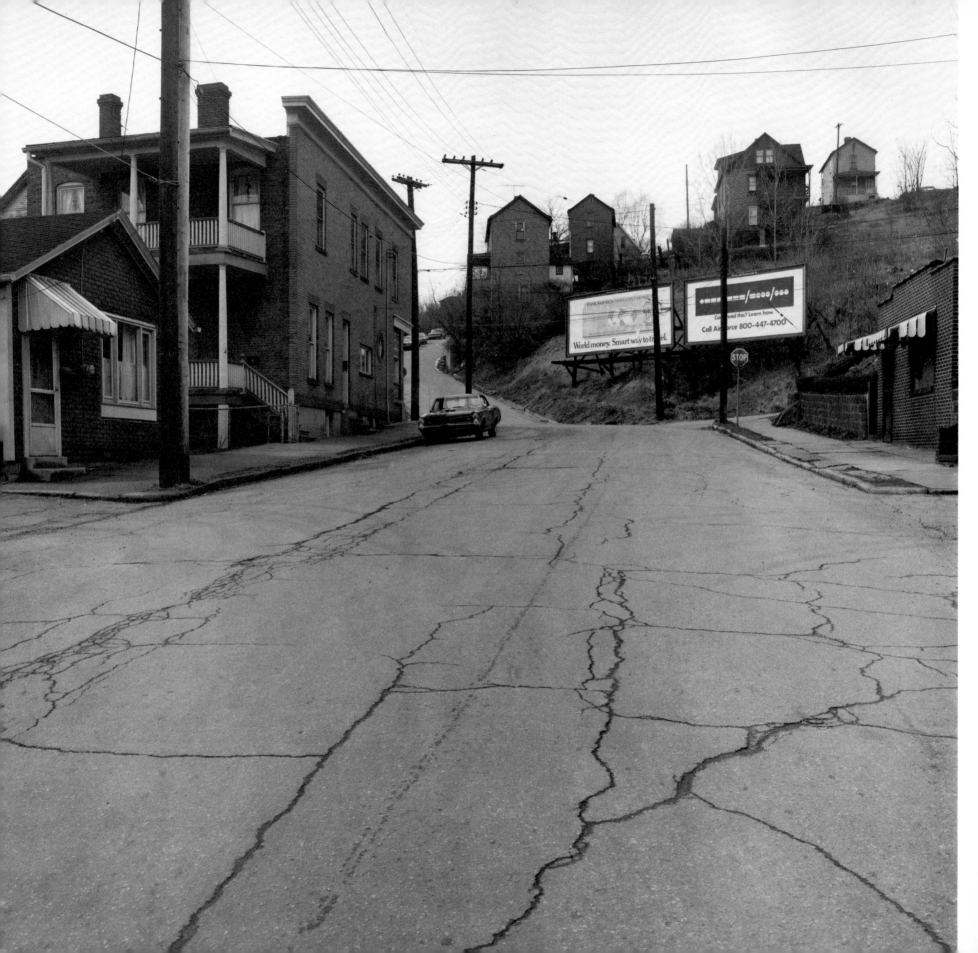

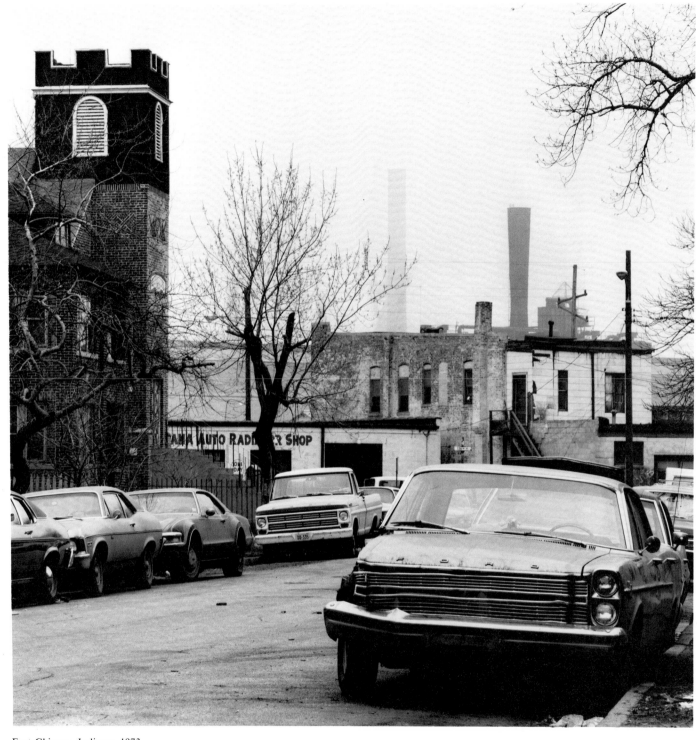

East Chicago, Indiana: 1973

111

Donora, Pennsylvania: 1974

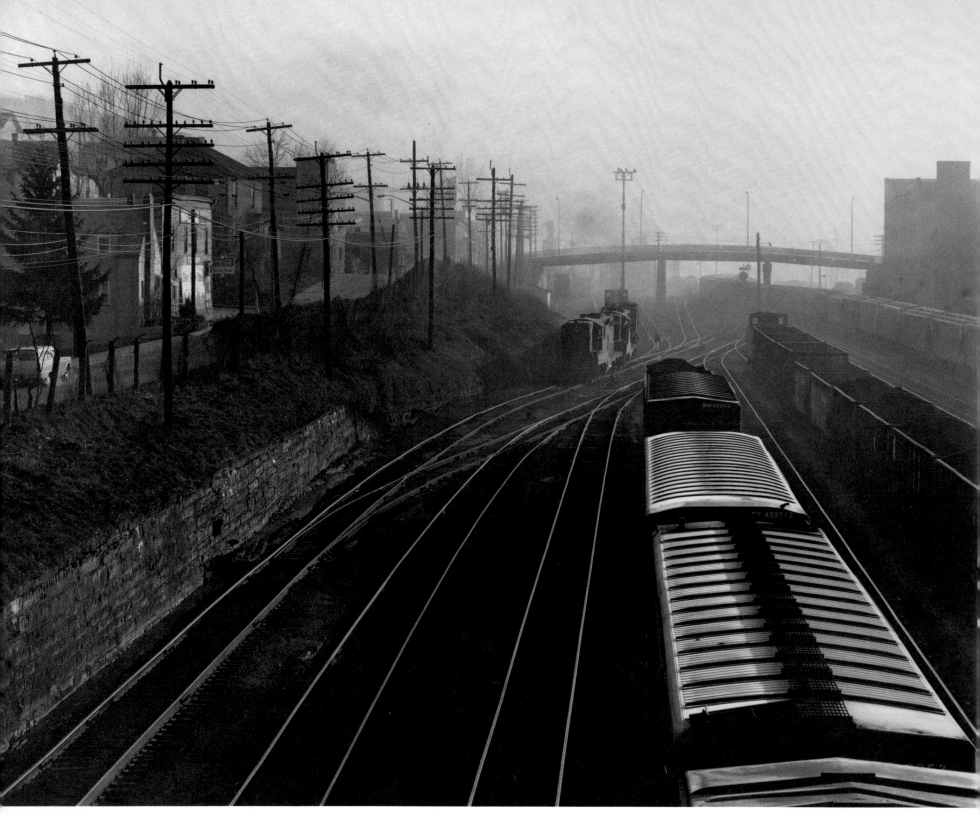

Bluefield, West Virginia: 1974

Youngstown, Ohio: 1973

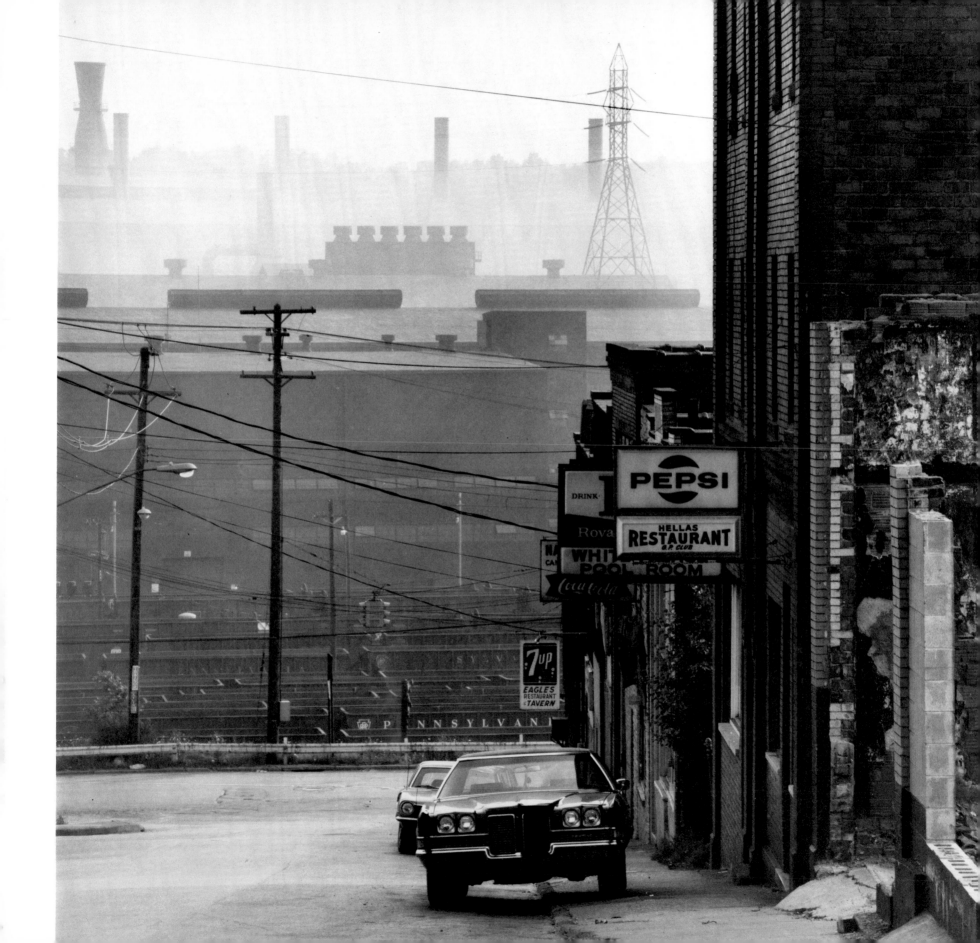

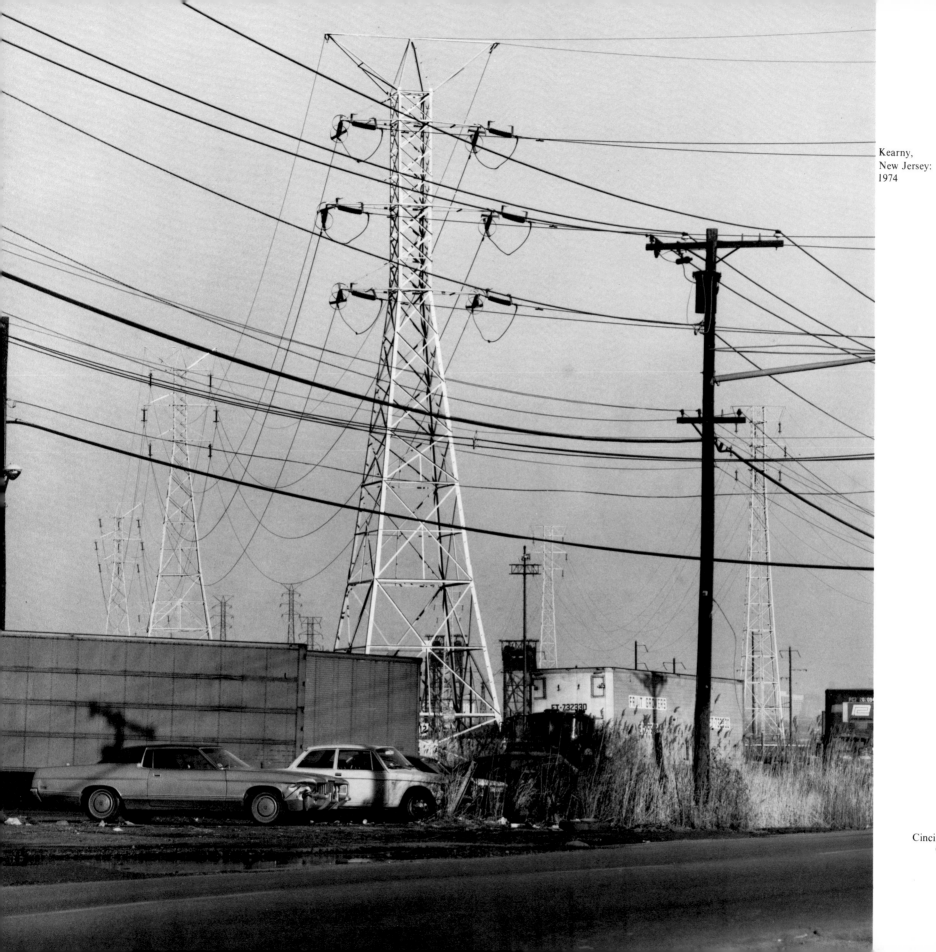

Kearny,
New Jersey:
1974

Cincinnati,
Ohio:
1966

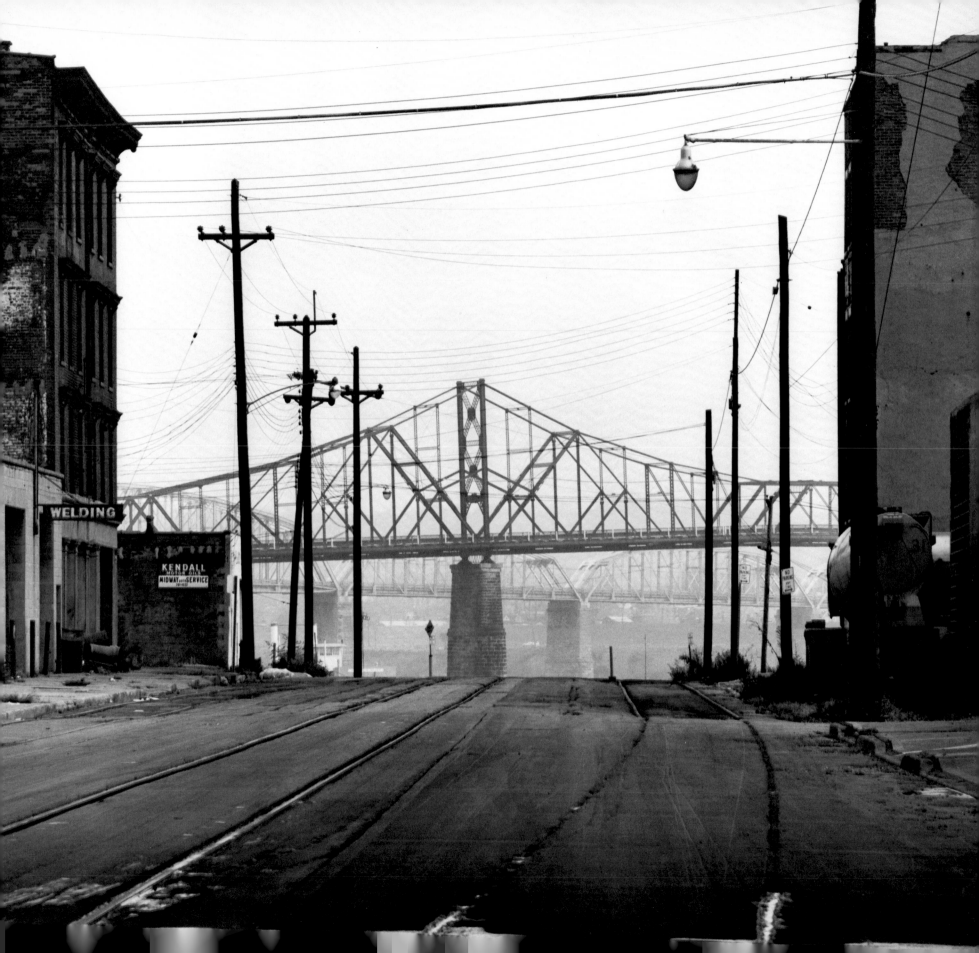

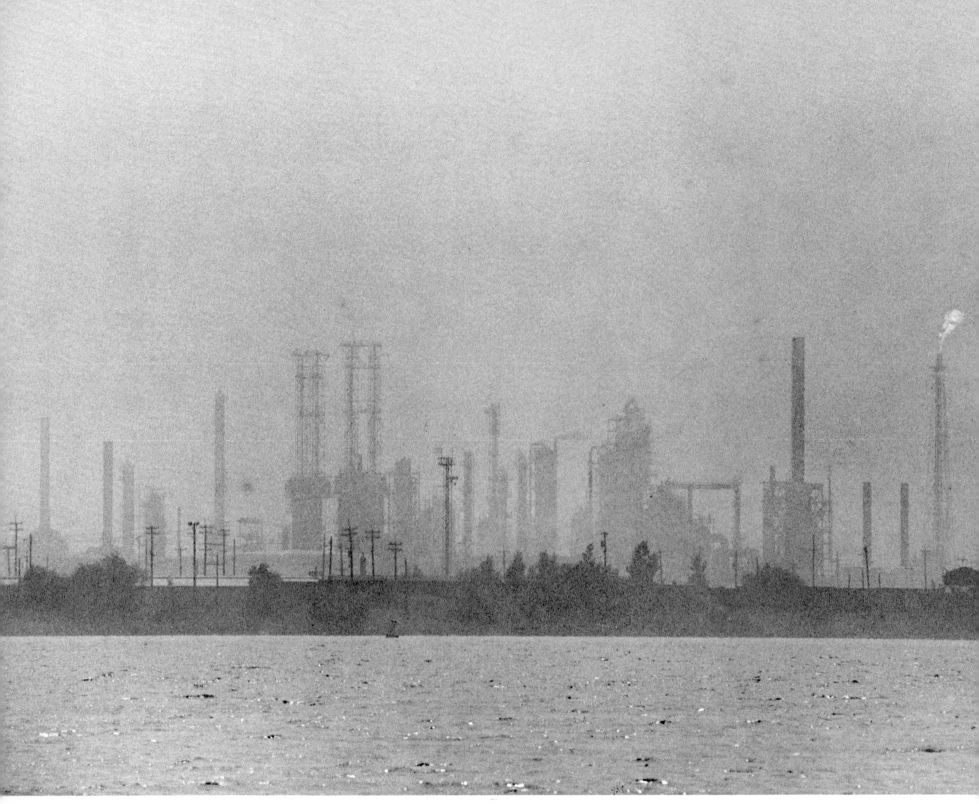

Toledo, Ohio: 1969

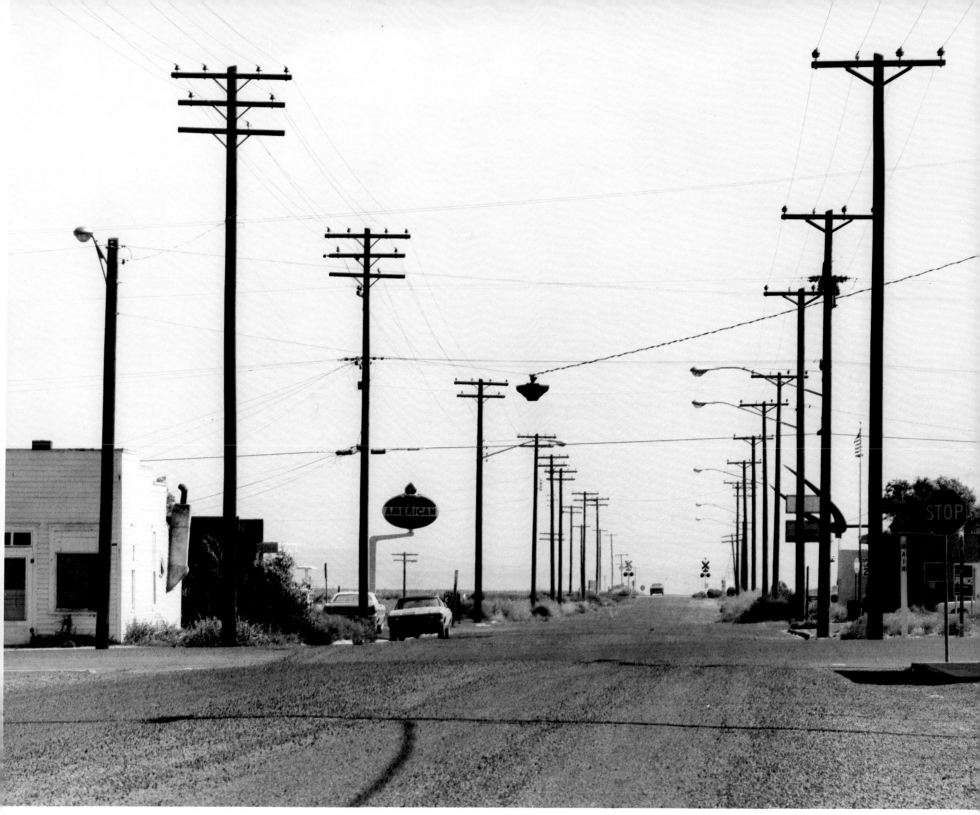

Warden, Washington: 1972

117

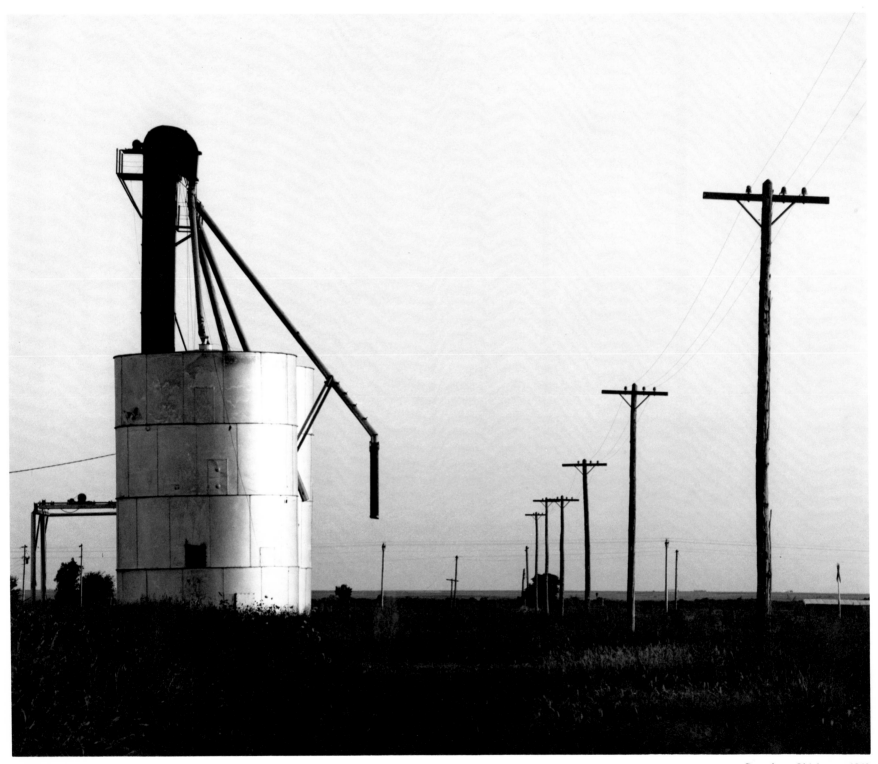

Geronimo, Oklahoma: 1969

Fergus County, Montana: 1973

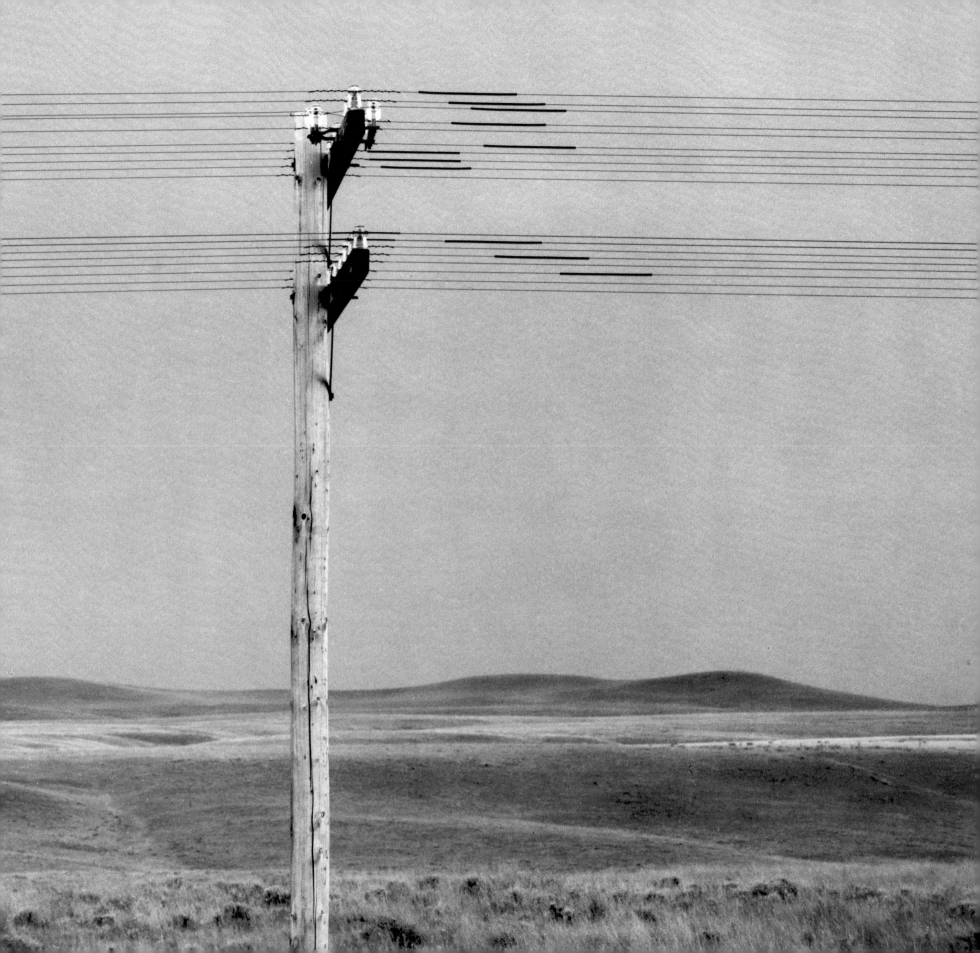